W9-ADN-289

nickelodeon

降世神通

AVATAR

THE LAST AIRBENDER

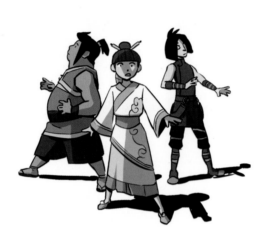

nickelodeon™

降击神通

AVATAR

THE LAST AIRBENDER™

 TOPH BEIFONG'S METALBENDING ACADEMY

Script
FAITH ERIN HICKS

Art
PETER WARTMAN

Colors
ADELE MATERA

Lettering
**RICHARD STARKINGS &
COMICRAFT'S JIMMY BETANCOURT**

DARK HORSE BOOKS

president and publisher
MIKE RICHARDSON

editor
RACHEL ROBERTS

assistant editor
JENNY BLENK

collection designer
SARAH TERRY

digital art technician
SAMANTHA HUMMER

martial arts consultant and model
TODD BALTHAZOR

Special thanks to Linda Lee, James Salerno, and Joan Hilty
at Nickelodeon, to Dave Marshall at Dark Horse, and to Bryan
Konietzko, Michael Dante DiMartino, and Tim Hedrick.

Nickelodeon Avatar: The Last Airbender™—Toph Beifong's Metalbending Academy
© 2021 Viacom International, Inc. All rights reserved. Nickelodeon, Nickelodeon Avatar: The Last
Airbender, and all related titles, logos, and characters are trademarks of Viacom International, Inc. All
other material, unless otherwise specified, is © 2021 Dark Horse Comics LLC. Dark Horse Books® and
the Dark Horse logo are registered trademarks of Dark Horse Comics LLC. All rights reserved. No portion
of this publication may be reproduced or transmitted, in any form or by any means, without the express
written permission of Dark Horse Comics LLC. Names, characters, places, and incidents featured in this
publication either are the product of the author's imagination or are used fictitiously. Any resemblance
to actual persons (living or dead), events, institutions, or locales, without satiric intent, is coincidental.

Published by **Dark Horse Books**
A division of **Dark Horse Comics LLC**
10956 SE Main Street | Milwaukie, OR 97222

DarkHorse.com
Nick.com

To find a comics shop in your area,
visit ComicShopLocator.com

First edition: February 2021
eBOOK ISBN 978-1-50671-715-9 | ISBN 978-1-50671-712-8

3 5 7 9 10 8 6 4 2
Printed in China

Neil Hankerson Executive Vice President • Tom Weddle Chief Financial Officer • Dale LaFountain
Chief Information Officer • Tim Wiesch Vice President of Licensing • Matt Parkinson Vice President
of Marketing • Vanessa Todd-Holmes Vice President of Production and Scheduling • Mark Bernardi
Vice President of Book Trade and Digital Sales • Randy Lahrman Vice President of Product
Development • Ken Lizzi General Counsel • Dave Marshall Editor in Chief • Davey Estrada Editorial
Director • Chris Warner Senior Books Editor • Cary Grazzini Director of Specialty Projects • Lia
Ribacchi Art Director • Matt Dryer Director of Digital Art and Prepress • Michael Gombos Senior
Director of Licensed Publications • Kari Yadro Director of Custom Programs • Kari Torson Director
of International Licensing

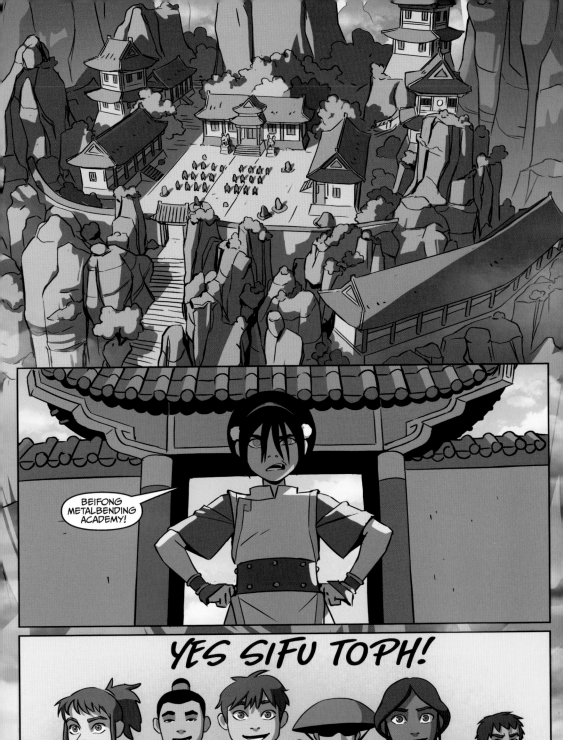

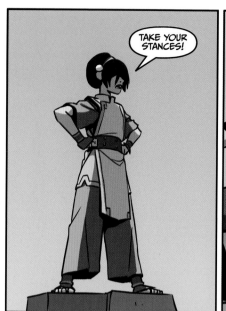

TAKE YOUR STANCES!

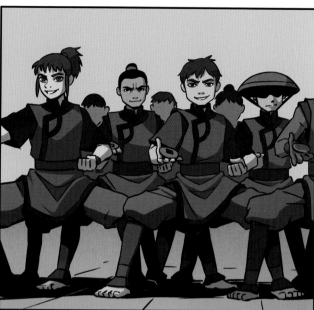

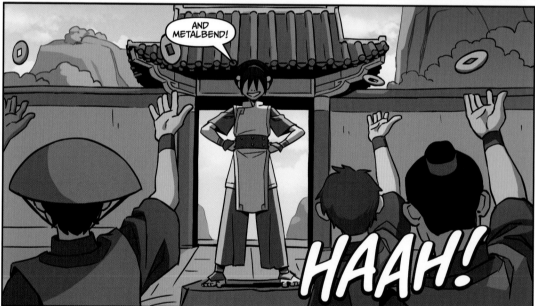

AND METALBEND!

HAAH!

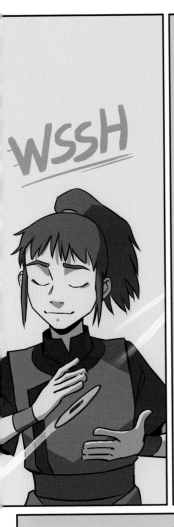

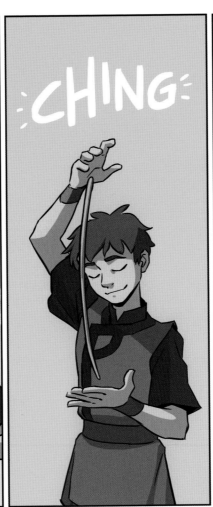

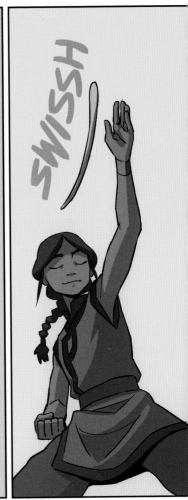

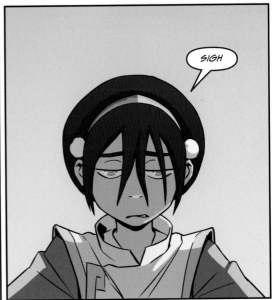

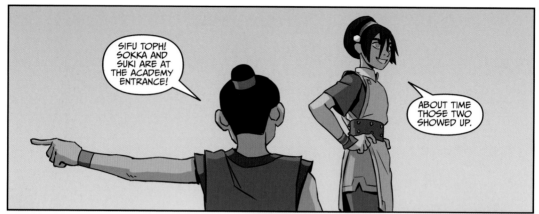

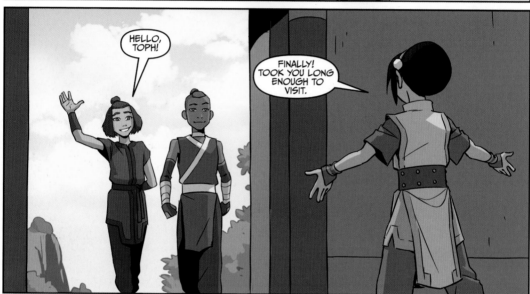

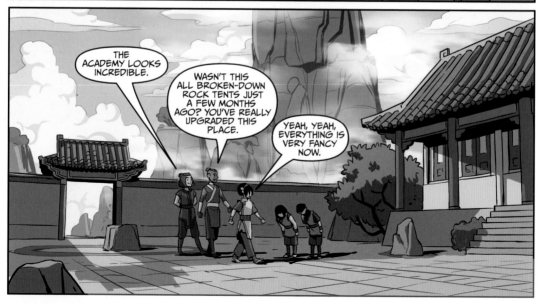

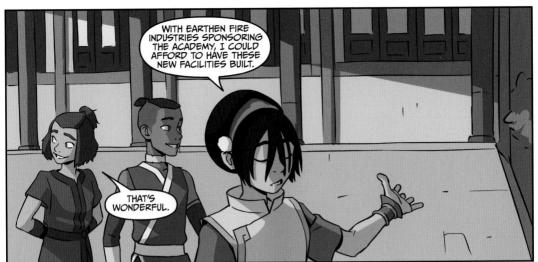

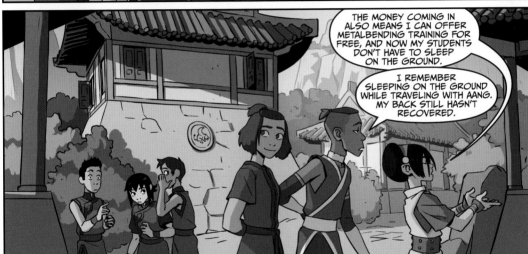

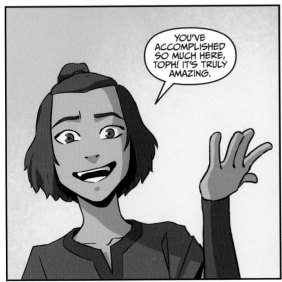

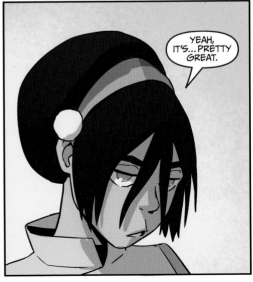

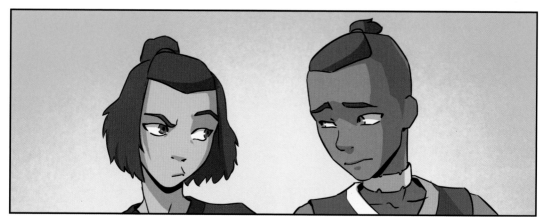

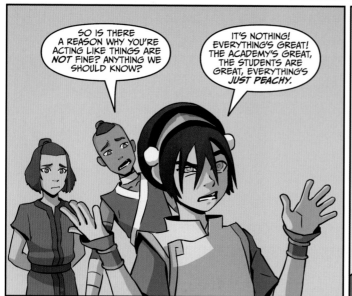

SO IS THERE A REASON WHY YOU'RE ACTING LIKE THINGS ARE *NOT* FINE? ANYTHING WE SHOULD KNOW?

IT'S NOTHING! EVERYTHING'S GREAT! THE ACADEMY'S GREAT, THE STUDENTS ARE GREAT, EVERYTHING'S *JUST PEACHY.*

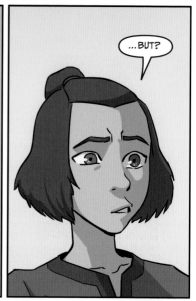

...BUT?

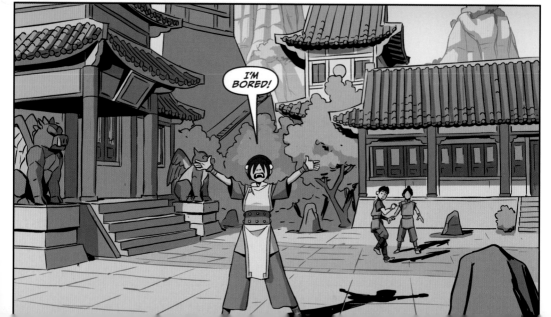

I'M BORED!

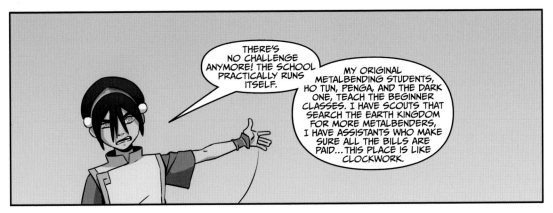

THERE'S NO CHALLENGE ANYMORE! THE SCHOOL PRACTICALLY RUNS ITSELF.

MY ORIGINAL METALBENDING STUDENTS, HO TUN, PENGA, AND THE DARK ONE, TEACH THE BEGINNER CLASSES. I HAVE SCOUTS THAT SEARCH THE EARTH KINGDOM FOR MORE METALBENDERS, I HAVE ASSISTANTS WHO MAKE SURE ALL THE BILLS ARE PAID... THIS PLACE IS LIKE CLOCKWORK.

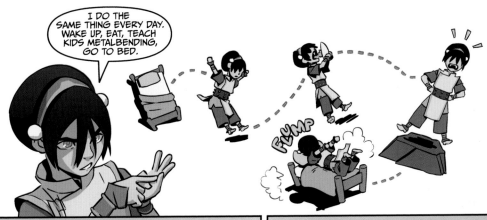

I DO THE SAME THING EVERY DAY. WAKE UP, EAT, TEACH KIDS METALBENDING, GO TO BED.

FLUMP

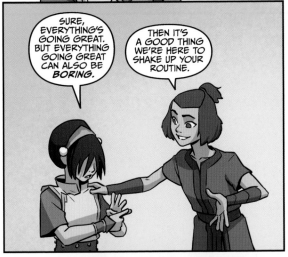

SURE, EVERYTHING'S GOING GREAT. BUT EVERYTHING GOING GREAT CAN ALSO BE *BORING*.

THEN IT'S A GOOD THING WE'RE HERE TO SHAKE UP YOUR ROUTINE.

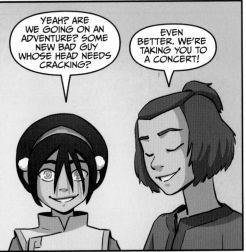

YEAH? ARE WE GOING ON AN ADVENTURE? SOME NEW BAD GUY WHOSE HEAD NEEDS CRACKING?

EVEN BETTER. WE'RE TAKING YOU TO A CONCERT!

YOU'RE WHAT NOW?

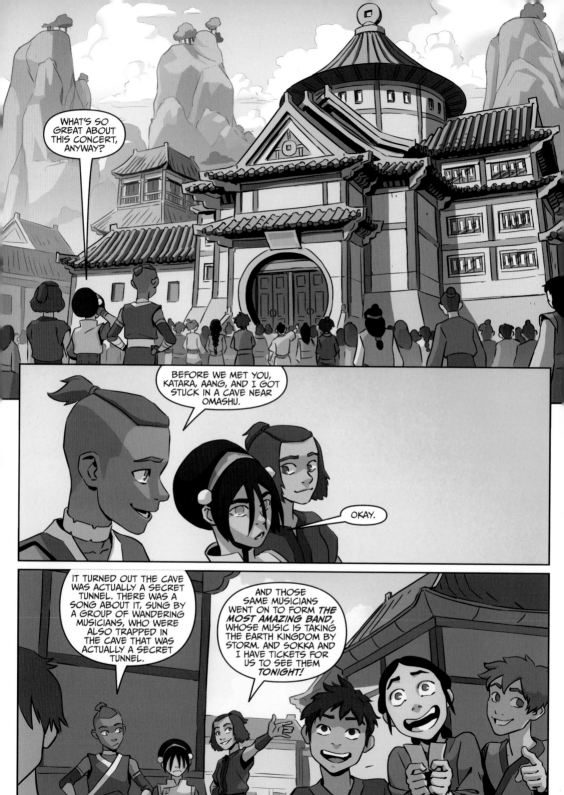

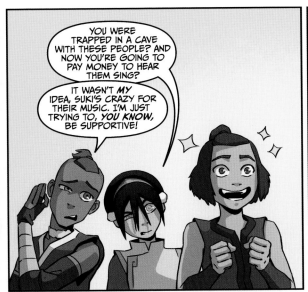

YOU WERE TRAPPED IN A CAVE WITH THESE PEOPLE? AND NOW YOU'RE GOING TO PAY MONEY TO HEAR THEM SING?

IT WASN'T *MY* IDEA, SUKI'S CRAZY FOR THEIR MUSIC. I'M JUST TRYING TO, *YOU KNOW*, BE SUPPORTIVE!

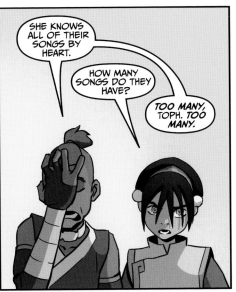

SHE KNOWS ALL OF THEIR SONGS BY HEART.

HOW MANY SONGS DO THEY HAVE?

TOO MANY, TOPH. *TOO MANY.*

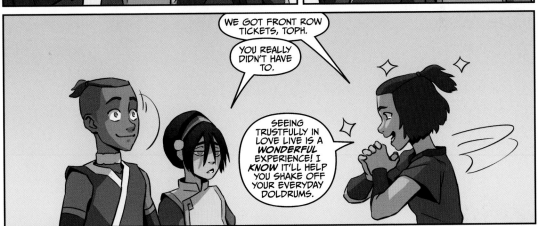

WE GOT FRONT ROW TICKETS, TOPH.

YOU REALLY DIDN'T HAVE TO.

SEEING TRUSTFULLY IN LOVE LIVE IS A *WONDERFUL* EXPERIENCE! I *KNOW* IT'LL HELP YOU SHAKE OFF YOUR EVERYDAY DOLDRUMS.

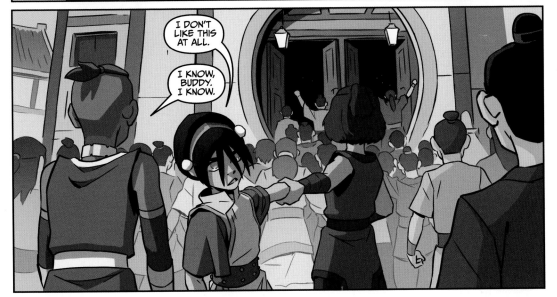

I DON'T LIKE THIS AT ALL.

I KNOW, BUDDY. I KNOW.

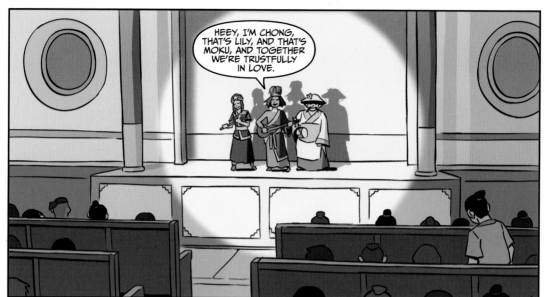

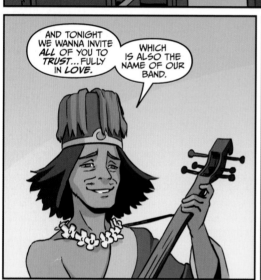

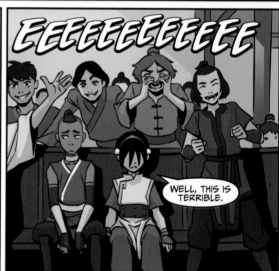

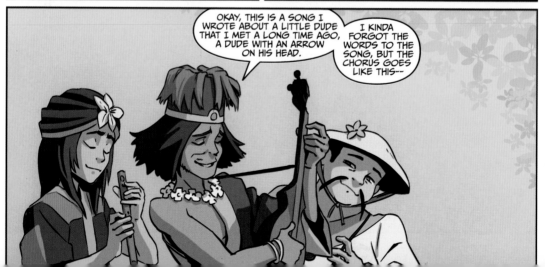

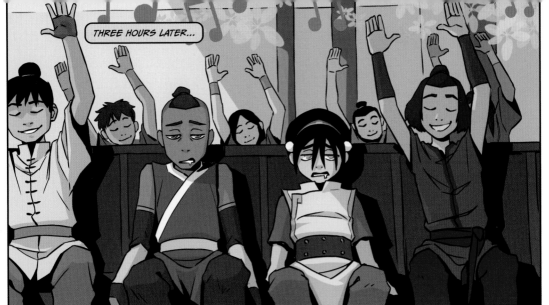

THREE HOURS LATER...

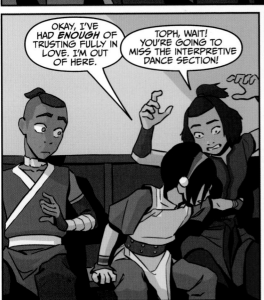

OKAY, I'VE HAD *ENOUGH* OF TRUSTING FULLY IN LOVE. I'M OUT OF HERE.

TOPH, WAIT! YOU'RE GOING TO MISS THE INTERPRETIVE DANCE SECTION!

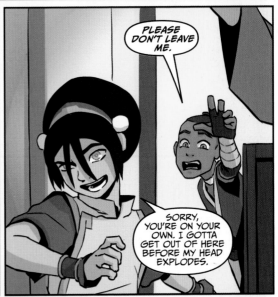

PLEASE DON'T LEAVE ME.

SORRY, YOU'RE ON YOUR OWN. I GOTTA GET OUT OF HERE BEFORE MY HEAD EXPLODES.

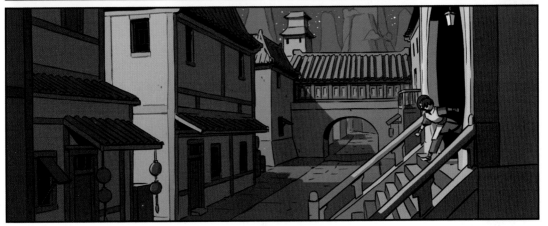

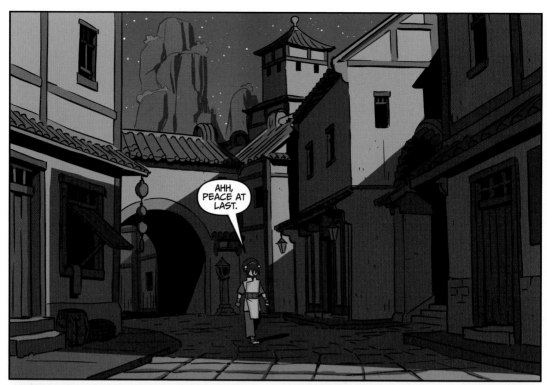

AHH, PEACE AT LAST.

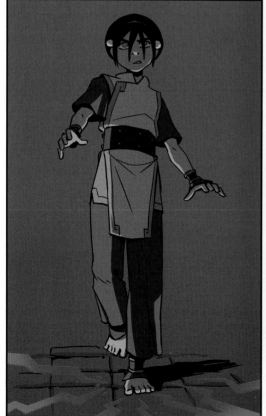

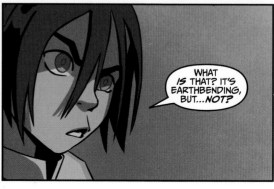

WHAT IS THAT? IT'S EARTHBENDING, BUT...NOT?

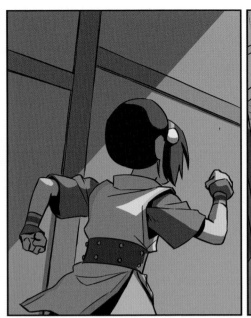
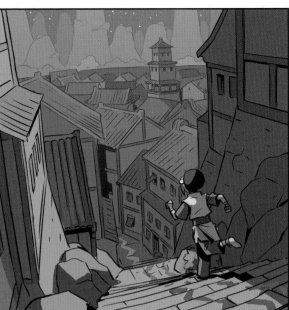

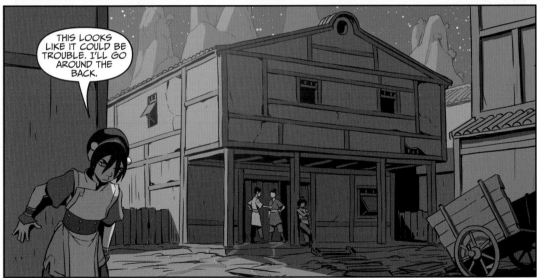

THIS LOOKS LIKE IT COULD BE TROUBLE. I'LL GO AROUND THE BACK.

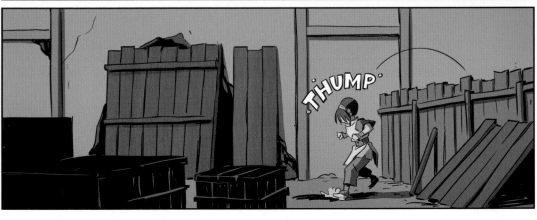

THUMP

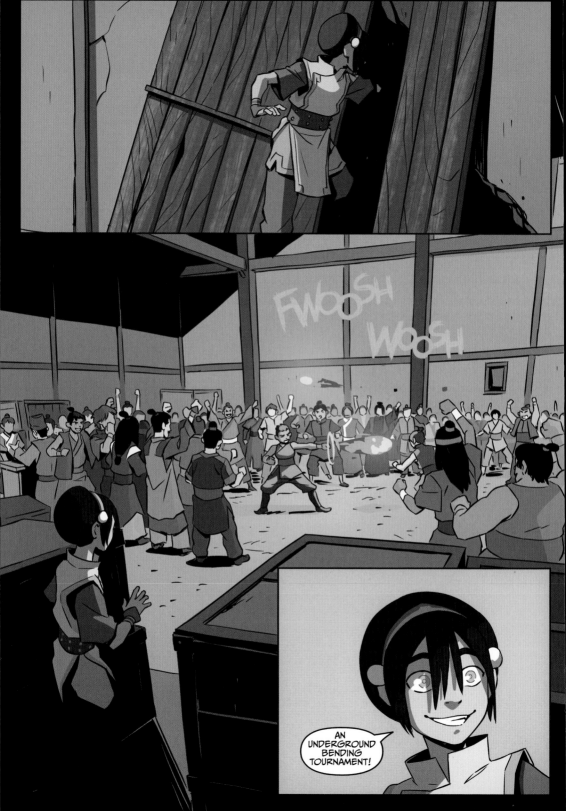

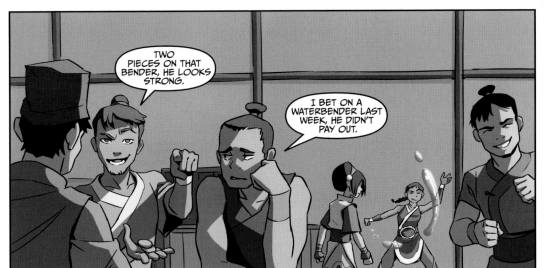

TWO PIECES ON THAT BENDER, HE LOOKS STRONG.

I BET ON A WATERBENDER LAST WEEK, HE DIDN'T PAY OUT.

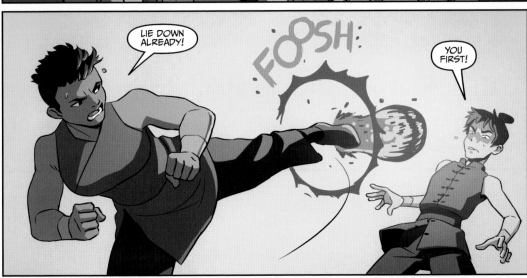

LIE DOWN ALREADY!

FOOSH

YOU FIRST!

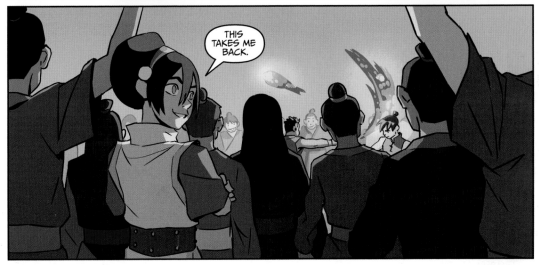

THIS TAKES ME BACK.

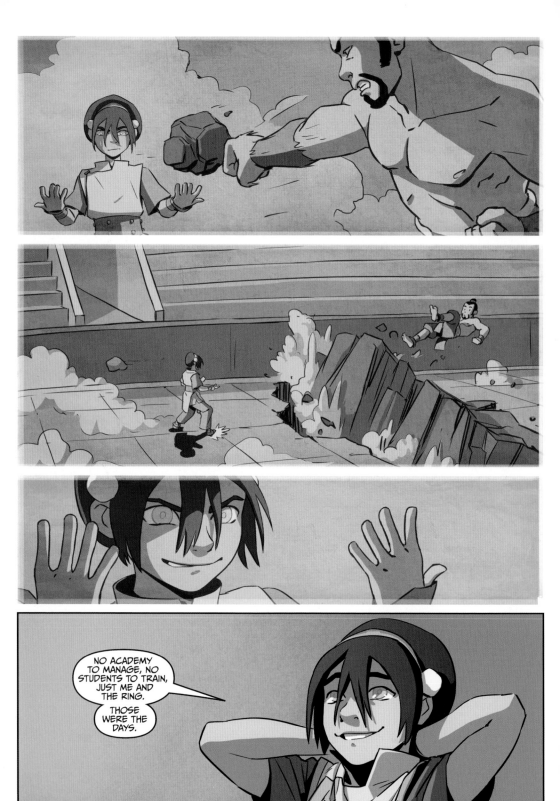

NO ACADEMY TO MANAGE, NO STUDENTS TO TRAIN, JUST ME AND THE RING.

THOSE WERE THE DAYS.

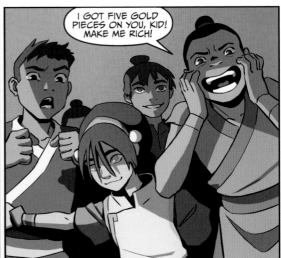
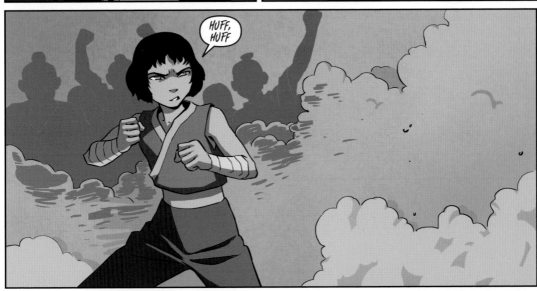
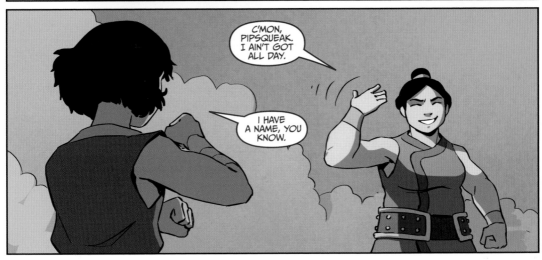

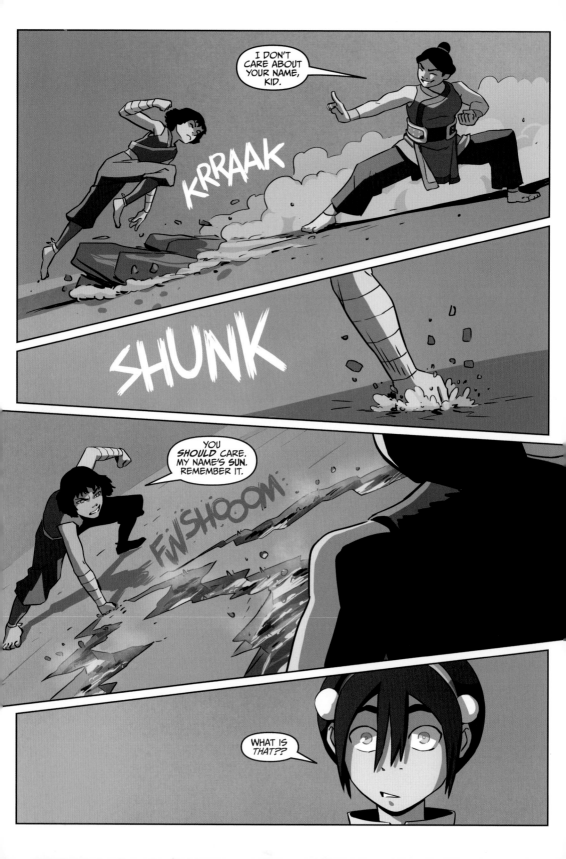

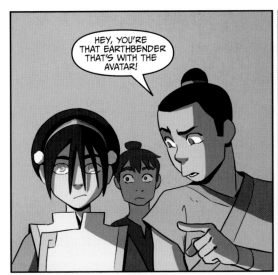

HEY, YOU'RE THAT EARTHBENDER THAT'S WITH THE AVATAR!

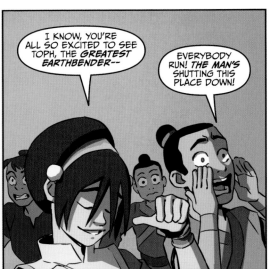

I KNOW, YOU'RE ALL SO EXCITED TO SEE TOPH, THE *GREATEST EARTHBENDER--*

EVERYBODY RUN! *THE MAN'S* SHUTTING THIS PLACE DOWN!

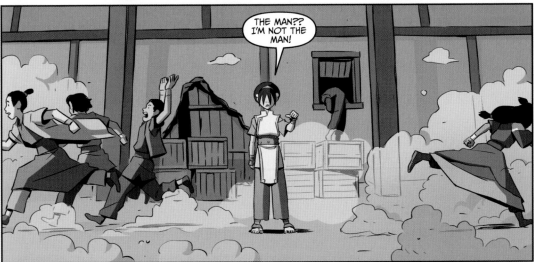

THE MAN?? I'M NOT THE MAN!

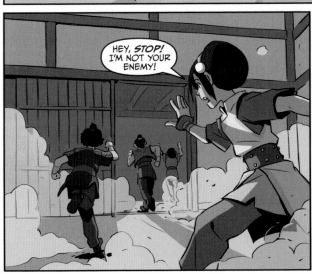

HEY, *STOP!* I'M NOT YOUR ENEMY!

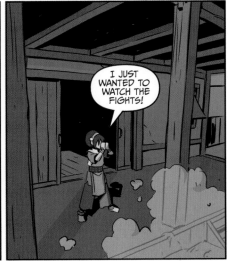

I JUST WANTED TO WATCH THE FIGHTS!

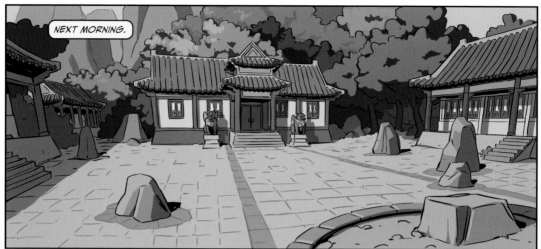

NEXT MORNING.

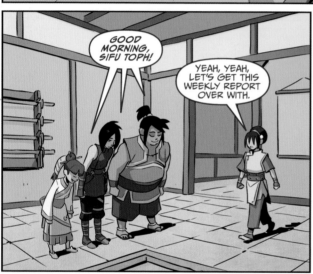

GOOD MORNING, SIFU TOPH!

YEAH, YEAH, LET'S GET THIS WEEKLY REPORT OVER WITH.

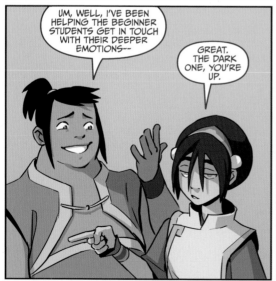

UM, WELL, I'VE BEEN HELPING THE BEGINNER STUDENTS GET IN TOUCH WITH THEIR DEEPER EMOTIONS--

GREAT. THE DARK ONE, YOU'RE UP.

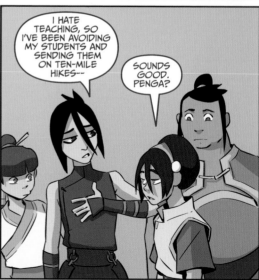

I HATE TEACHING, SO I'VE BEEN AVOIDING MY STUDENTS AND SENDING THEM ON TEN-MILE HIKES--

SOUNDS GOOD. PENGA?

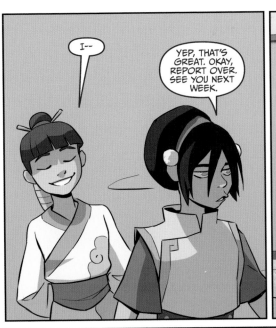

I--

YEP, THAT'S GREAT. OKAY, REPORT OVER. SEE YOU NEXT WEEK.

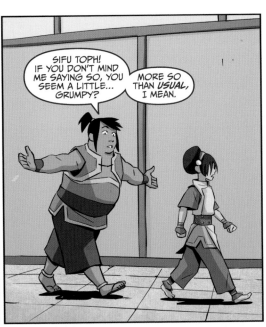

SIFU TOPH! IF YOU DON'T MIND ME SAYING SO, YOU SEEM A LITTLE... GRUMPY?

MORE SO THAN *USUAL*, I MEAN.

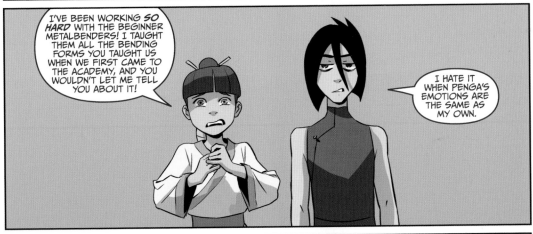

I'VE BEEN WORKING *SO HARD* WITH THE BEGINNER METALBENDERS! I TAUGHT THEM ALL THE BENDING FORMS YOU TAUGHT US WHEN WE FIRST CAME TO THE ACADEMY, AND YOU WOULDN'T LET ME TELL YOU ABOUT IT!

I HATE IT WHEN PENGA'S EMOTIONS ARE THE SAME AS MY OWN.

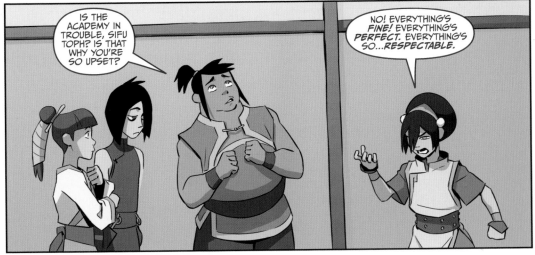

IS THE ACADEMY IN TROUBLE, SIFU TOPH? IS THAT WHY YOU'RE SO UPSET?

NO! EVERYTHING'S *FINE!* EVERYTHING'S *PERFECT.* EVERYTHING'S SO...*RESPECTABLE.*

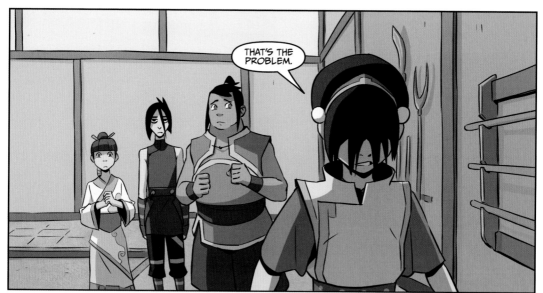

THAT'S THE PROBLEM.

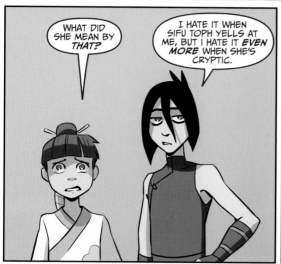

WHAT DID SHE MEAN BY *THAT?*

I HATE IT WHEN SIFU TOPH YELLS AT ME, BUT I HATE IT *EVEN MORE* WHEN SHE'S CRYPTIC.

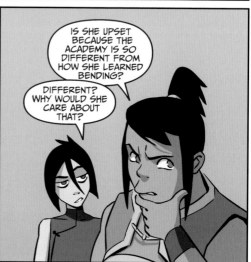

IS SHE UPSET BECAUSE THE ACADEMY IS SO DIFFERENT FROM HOW SHE LEARNED BENDING?

DIFFERENT? WHY WOULD SHE CARE ABOUT THAT?

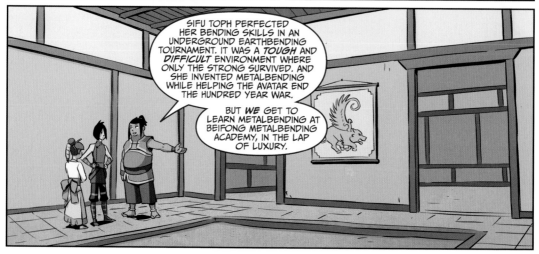

SIFU TOPH PERFECTED HER BENDING SKILLS IN AN UNDERGROUND EARTHBENDING TOURNAMENT. IT WAS A *TOUGH* AND *DIFFICULT* ENVIRONMENT WHERE ONLY THE STRONG SURVIVED. AND SHE INVENTED METALBENDING WHILE HELPING THE AVATAR END THE HUNDRED YEAR WAR.

BUT *WE* GET TO LEARN METALBENDING AT BEIFONG METALBENDING ACADEMY, IN THE LAP OF LUXURY.

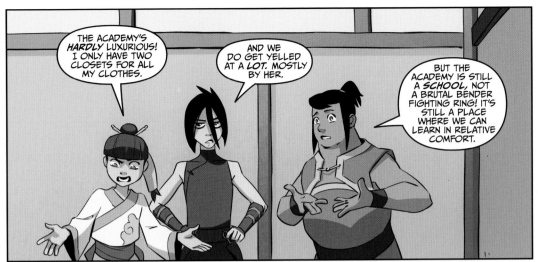

THE ACADEMY'S *HARDLY* LUXURIOUS! I ONLY HAVE TWO CLOSETS FOR ALL MY CLOTHES.

AND WE DO GET YELLED AT A *LOT.* MOSTLY BY HER.

BUT THE ACADEMY IS STILL A *SCHOOL,* NOT A BRUTAL BENDER FIGHTING RING! IT'S STILL A PLACE WHERE WE CAN LEARN IN RELATIVE COMFORT.

AND BECAUSE OF THE ACADEMY WE'VE GROWN SO MUCH, HAVEN'T WE? REMEMBER WHAT WE WERE LIKE WHEN WE FIRST CAME HERE?

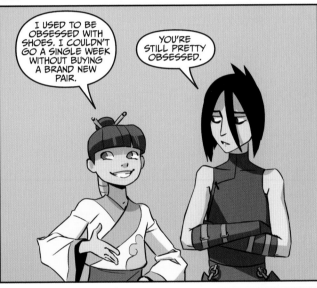

I USED TO BE OBSESSED WITH SHOES. I COULDN'T GO A SINGLE WEEK WITHOUT BUYING A BRAND NEW PAIR.

YOU'RE STILL PRETTY OBSESSED.

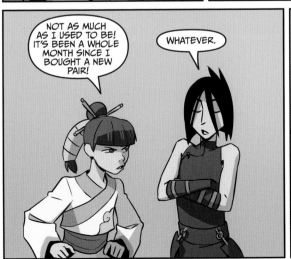

NOT AS MUCH AS I USED TO BE! IT'S BEEN A WHOLE MONTH SINCE I BOUGHT A NEW PAIR!

WHATEVER.

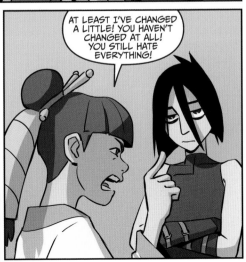

AT LEAST I'VE CHANGED A LITTLE! YOU HAVEN'T CHANGED AT ALL! YOU STILL HATE EVERYTHING!

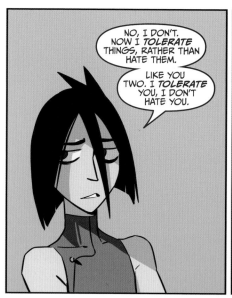

NO, I DON'T. NOW I *TOLERATE* THINGS, RATHER THAN HATE THEM.

LIKE YOU TWO. I *TOLERATE* YOU, I DON'T HATE YOU.

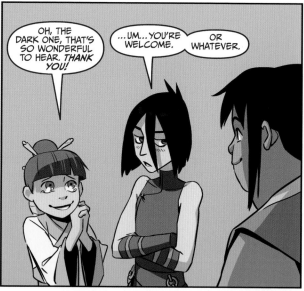

OH, THE DARK ONE, THAT'S SO WONDERFUL TO HEAR. *THANK YOU!*

...UM...YOU'RE WELCOME.

OR WHATEVER.

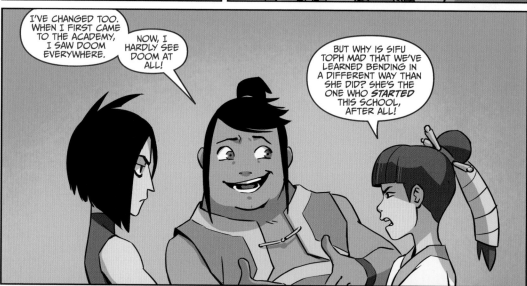

I'VE CHANGED TOO. WHEN I FIRST CAME TO THE ACADEMY, I SAW DOOM EVERYWHERE.

NOW, I HARDLY SEE DOOM AT ALL!

BUT WHY IS SIFU TOPH MAD THAT WE'VE LEARNED BENDING IN A DIFFERENT WAY THAN SHE DID? SHE'S THE ONE WHO *STARTED* THIS SCHOOL, AFTER ALL!

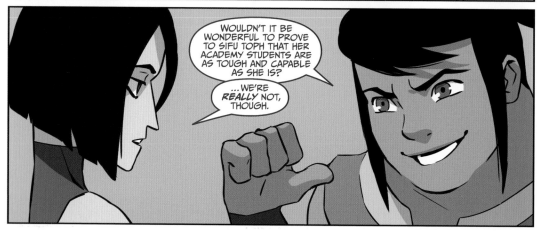

WOULDN'T IT BE WONDERFUL TO PROVE TO SIFU TOPH THAT HER ACADEMY STUDENTS ARE AS TOUGH AND CAPABLE AS SHE IS?

...WE'RE *REALLY* NOT, THOUGH.

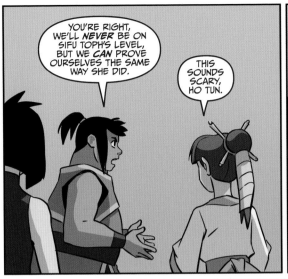

YOU'RE RIGHT, WE'LL *NEVER* BE ON SIFU TOPH'S LEVEL, BUT WE *CAN* PROVE OURSELVES THE SAME WAY SHE DID.

THIS SOUNDS SCARY, HO TUN.

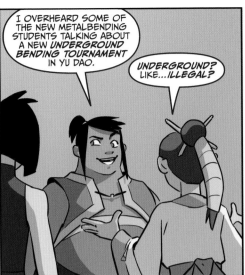

I OVERHEARD SOME OF THE NEW METALBENDING STUDENTS TALKING ABOUT A NEW *UNDERGROUND BENDING TOURNAMENT* IN YU DAO.

UNDERGROUND? LIKE...*ILLEGAL?*

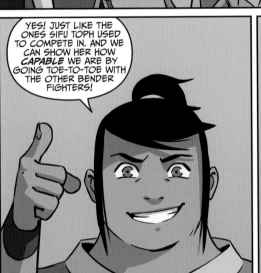

YES! JUST LIKE THE ONES SIFU TOPH USED TO COMPETE IN. AND WE CAN SHOW HER HOW *CAPABLE* WE ARE BY GOING TOE-TO-TOE WITH THE OTHER BENDER FIGHTERS!

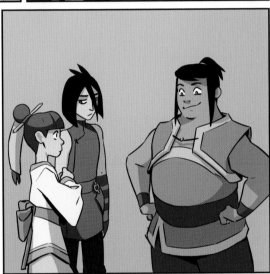

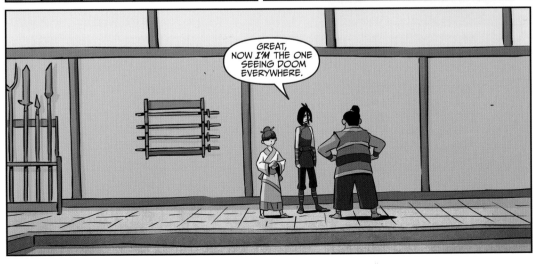

GREAT, NOW *I'M* THE ONE SEEING DOOM EVERYWHERE.

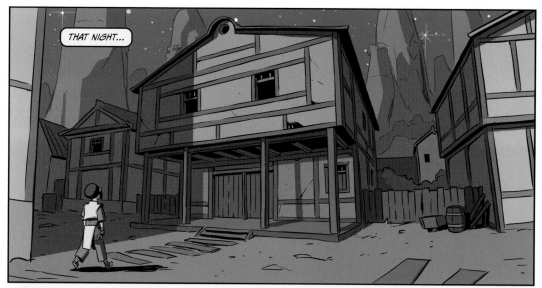

THAT NIGHT...

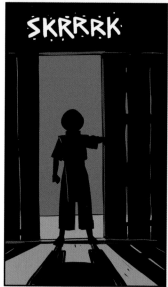

SKRRRK

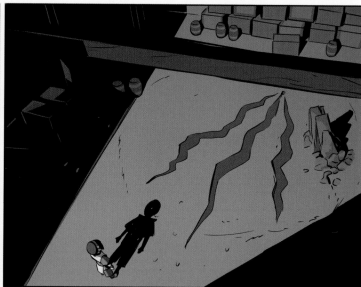

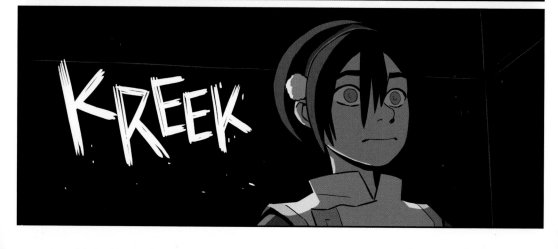

KREEK

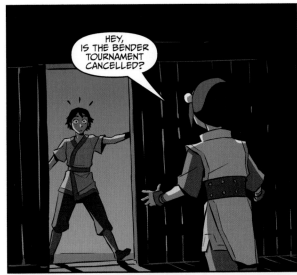

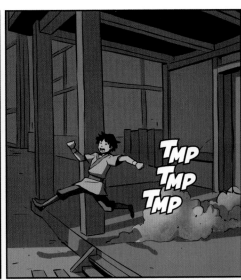

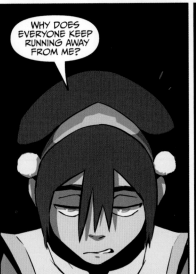

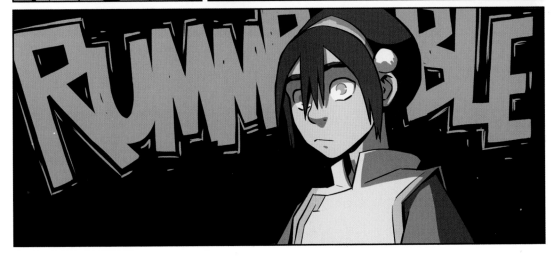

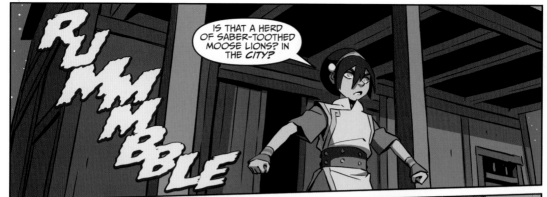

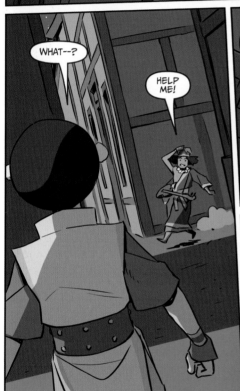

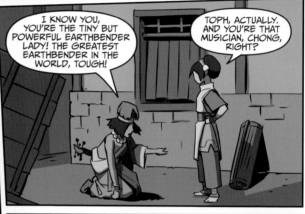

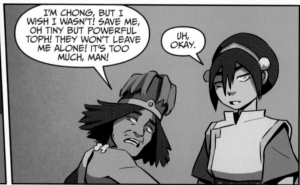

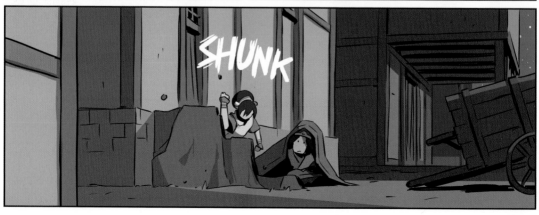

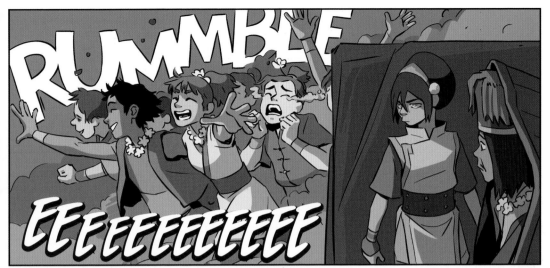

RUMMBLE

EEEEEEEEEEE

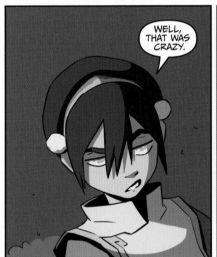

WELL, THAT WAS CRAZY.

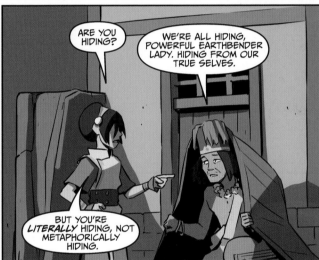

ARE YOU HIDING?

WE'RE ALL HIDING, POWERFUL EARTHBENDER LADY. HIDING FROM OUR TRUE SELVES.

BUT YOU'RE *LITERALLY* HIDING, NOT METAPHORICALLY HIDING.

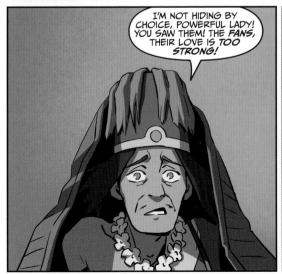

I'M NOT HIDING BY CHOICE, POWERFUL LADY! YOU SAW THEM! THE *FANS*, THEIR LOVE IS *TOO STRONG!*

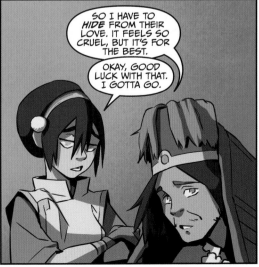

SO I HAVE TO *HIDE* FROM THEIR LOVE. IT FEELS SO CRUEL, BUT IT'S FOR THE BEST.

OKAY, GOOD LUCK WITH THAT. I GOTTA GO.

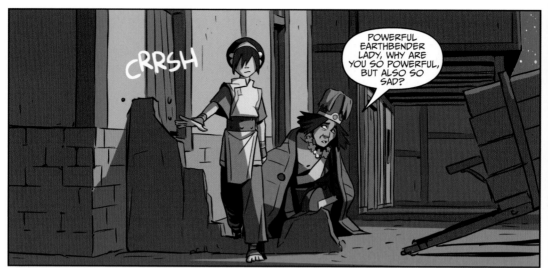

CRRSH

POWERFUL EARTHBENDER LADY, WHY ARE YOU SO POWERFUL, BUT ALSO SO SAD?

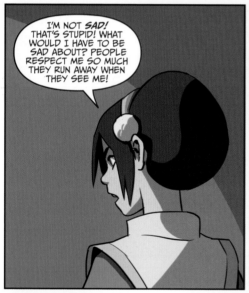

I'M NOT *SAD!* THAT'S STUPID! WHAT WOULD I HAVE TO BE SAD ABOUT? PEOPLE RESPECT ME SO MUCH THEY RUN AWAY WHEN THEY SEE ME!

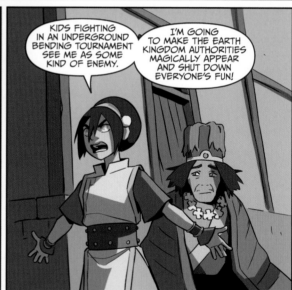

KIDS FIGHTING IN AN UNDERGROUND BENDING TOURNAMENT SEE ME AS SOME KIND OF ENEMY.

I'M GOING TO MAKE THE EARTH KINGDOM AUTHORITIES MAGICALLY APPEAR AND SHUT DOWN EVERYONE'S FUN!

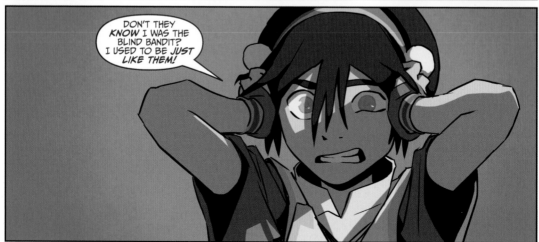

DON'T THEY *KNOW* I WAS THE BLIND BANDIT? I USED TO BE *JUST LIKE THEM!*

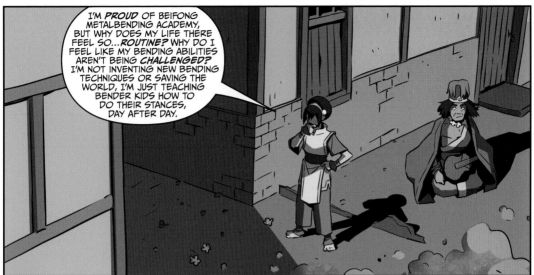

I'M **PROUD** OF BEIFONG METALBENDING ACADEMY, BUT WHY DOES MY LIFE THERE FEEL SO...**ROUTINE?** WHY DO I FEEL LIKE MY BENDING ABILITIES AREN'T BEING **CHALLENGED?** I'M NOT INVENTING NEW BENDING TECHNIQUES OR SAVING THE WORLD, I'M JUST TEACHING BENDER KIDS HOW TO DO THEIR STANCES, DAY AFTER DAY.

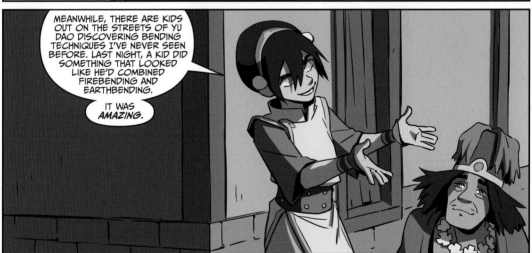

MEANWHILE, THERE ARE KIDS OUT ON THE STREETS OF YU DAO DISCOVERING BENDING TECHNIQUES I'VE NEVER SEEN BEFORE. LAST NIGHT, A KID DID SOMETHING THAT LOOKED LIKE HE'D COMBINED FIREBENDING AND EARTHBENDING.

IT WAS **AMAZING.**

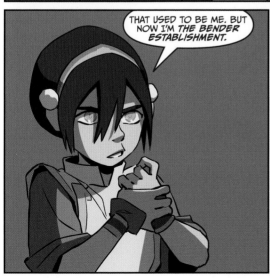

THAT USED TO BE ME. BUT NOW I'M **THE BENDER ESTABLISHMENT.**

I GET IT, POWERFUL EARTHBENDER LADY.

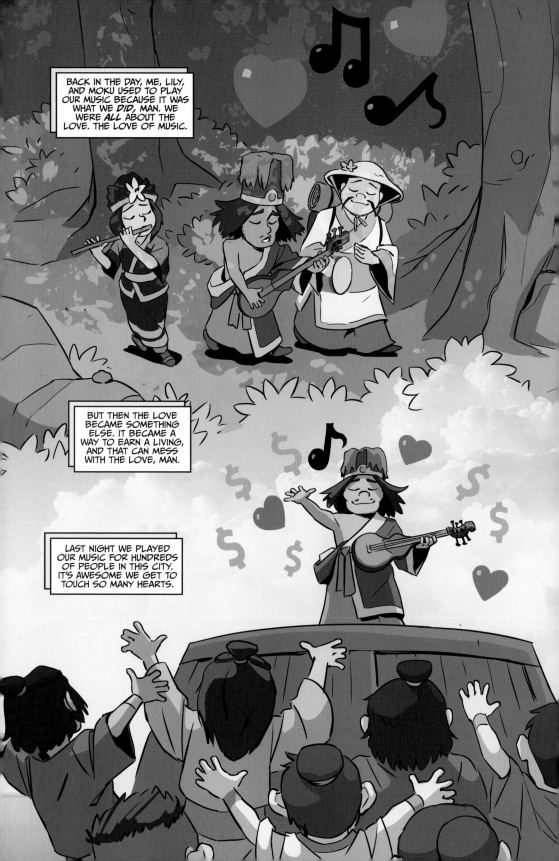

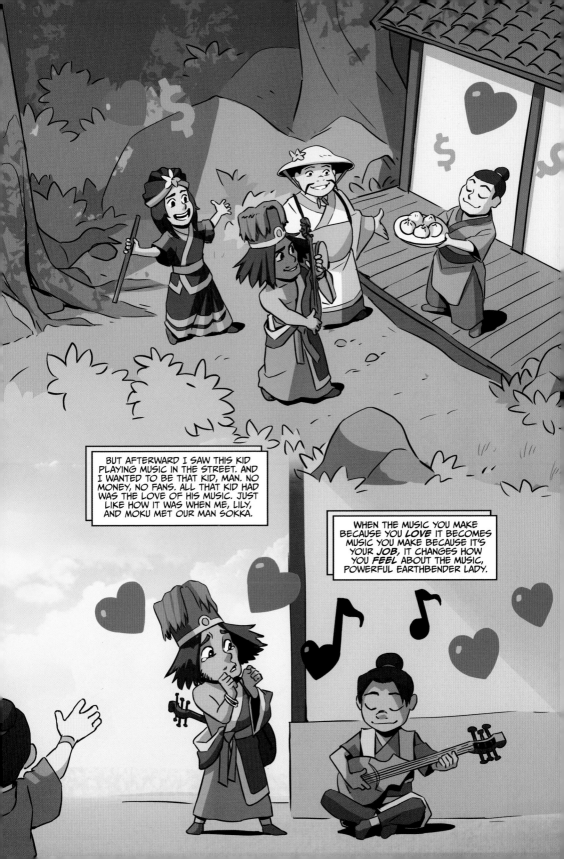

BUT AFTERWARD I SAW THIS KID PLAYING MUSIC IN THE STREET. AND I WANTED TO BE THAT KID, MAN. NO MONEY, NO FANS. ALL THAT KID HAD WAS THE LOVE OF HIS MUSIC. JUST LIKE HOW IT WAS WHEN ME, LILY, AND MOKU MET OUR MAN SOKKA.

WHEN THE MUSIC YOU MAKE BECAUSE YOU *LOVE* IT BECOMES MUSIC YOU MAKE BECAUSE IT'S YOUR *JOB*, IT CHANGES HOW YOU *FEEL* ABOUT THE MUSIC, POWERFUL EARTHBENDER LADY.

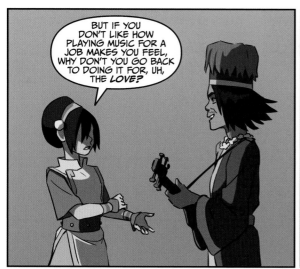

BUT IF YOU DON'T LIKE HOW PLAYING MUSIC FOR A JOB MAKES YOU FEEL, WHY DON'T YOU GO BACK TO DOING IT FOR, UH, THE *LOVE?*

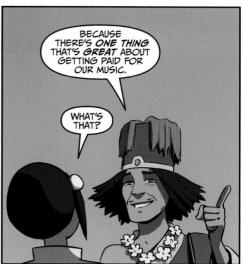

BECAUSE THERE'S *ONE THING* THAT'S *GREAT* ABOUT GETTING PAID FOR OUR MUSIC.

WHAT'S THAT?

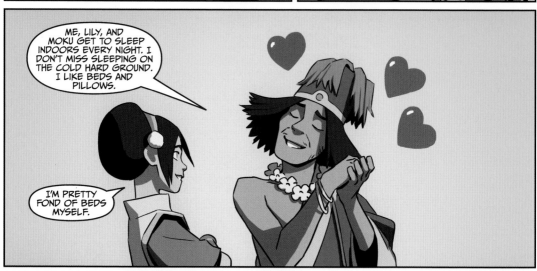

ME, LILY, AND MOKU GET TO SLEEP INDOORS EVERY NIGHT. I DON'T MISS SLEEPING ON THE COLD HARD GROUND. I LIKE BEDS AND PILLOWS.

I'M PRETTY FOND OF BEDS MYSELF.

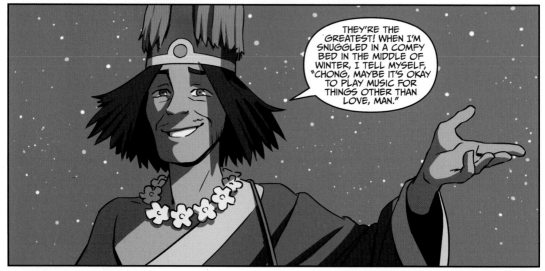

THEY'RE THE GREATEST! WHEN I'M SNUGGLED IN A COMFY BED IN THE MIDDLE OF WINTER, I TELL MYSELF, "CHONG, MAYBE IT'S OKAY TO PLAY MUSIC FOR THINGS OTHER THAN LOVE, MAN."

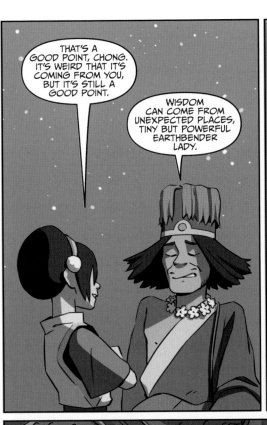

THAT'S A GOOD POINT, CHONG. IT'S WEIRD THAT IT'S COMING FROM YOU, BUT IT'S STILL A GOOD POINT.

WISDOM CAN COME FROM UNEXPECTED PLACES, TINY BUT POWERFUL EARTHBENDER LADY.

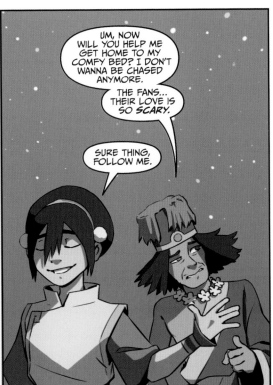

UM, NOW WILL YOU HELP ME GET HOME TO MY COMFY BED? I DON'T WANNA BE CHASED ANYMORE.

THE FANS... THEIR LOVE IS SO *SCARY*.

SURE THING, FOLLOW ME.

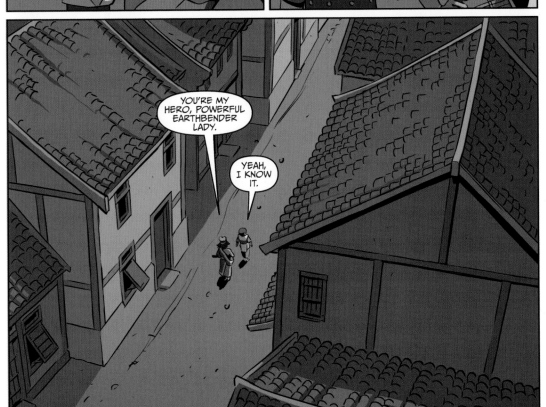

YOU'RE MY HERO, POWERFUL EARTHBENDER LADY.

YEAH, I KNOW IT.

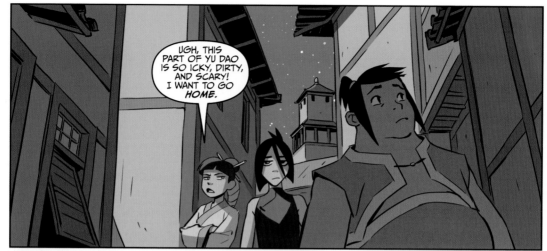

UGH, THIS PART OF YU DAO IS SO ICKY, DIRTY, AND SCARY! I WANT TO GO *HOME.*

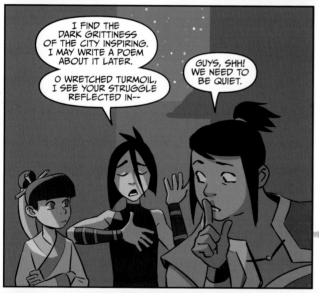

I FIND THE DARK GRITTINESS OF THE CITY INSPIRING. I MAY WRITE A POEM ABOUT IT LATER.

O WRETCHED TURMOIL, I SEE YOUR STRUGGLE REFLECTED IN--

GUYS, SHH! WE NEED TO BE QUIET.

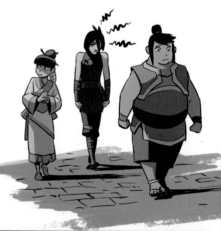

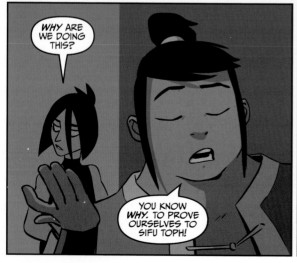

WHY ARE WE DOING THIS?

YOU KNOW *WHY.* TO PROVE OURSELVES TO SIFU TOPH!

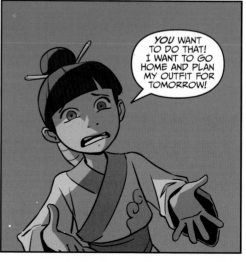

YOU WANT TO DO THAT! I WANT TO GO HOME AND PLAN MY OUTFIT FOR TOMORROW!

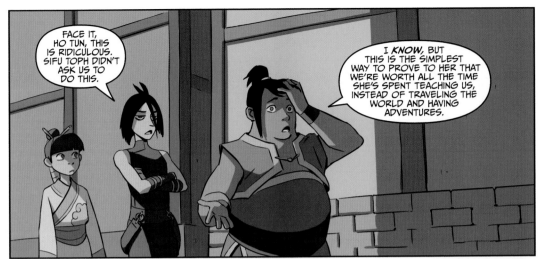

FACE IT, HO TUN, THIS IS RIDICULOUS. SIFU TOPH DIDN'T ASK US TO DO THIS.

I *KNOW*, BUT THIS IS THE SIMPLEST WAY TO PROVE TO HER THAT WE'RE WORTH ALL THE TIME SHE'S SPENT TEACHING US, INSTEAD OF TRAVELING THE WORLD AND HAVING ADVENTURES.

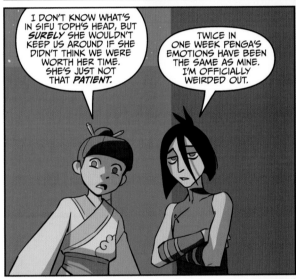

I DON'T KNOW WHAT'S IN SIFU TOPH'S HEAD, BUT *SURELY* SHE WOULDN'T KEEP US AROUND IF SHE DIDN'T THINK WE WERE WORTH HER TIME. SHE'S JUST NOT THAT *PATIENT*.

TWICE IN ONE WEEK PENGA'S EMOTIONS HAVE BEEN THE SAME AS MINE. I'M OFFICIALLY WEIRDED OUT.

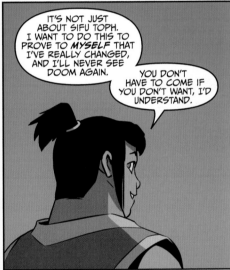

IT'S NOT JUST ABOUT SIFU TOPH. I WANT TO DO THIS TO PROVE TO *MYSELF* THAT I'VE REALLY CHANGED, AND I'LL NEVER SEE DOOM AGAIN.

YOU DON'T HAVE TO COME IF YOU DON'T WANT, I'D UNDERSTAND.

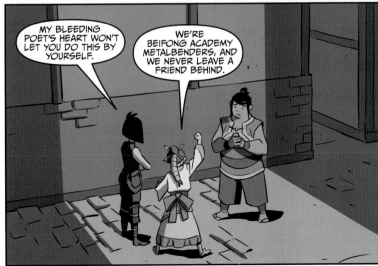

MY BLEEDING POET'S HEART WON'T LET YOU DO THIS BY YOURSELF.

WE'RE BEIFONG ACADEMY METALBENDERS, AND WE NEVER LEAVE A FRIEND BEHIND.

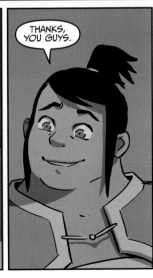

THANKS, YOU GUYS.

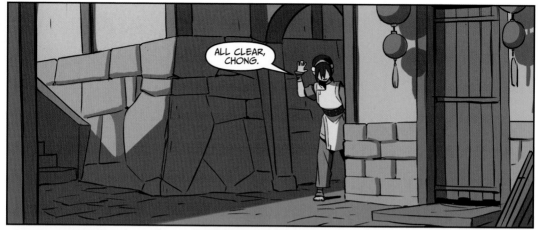

ALL CLEAR, CHONG.

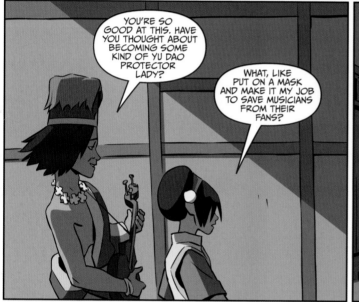

YOU'RE SO GOOD AT THIS. HAVE YOU THOUGHT ABOUT BECOMING SOME KIND OF YU DAO PROTECTOR LADY?

WHAT, LIKE PUT ON A MASK AND MAKE IT MY JOB TO SAVE MUSICIANS FROM THEIR FANS?

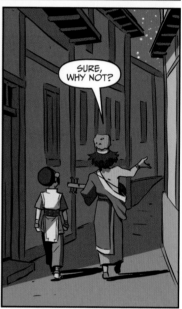

SURE, WHY NOT?

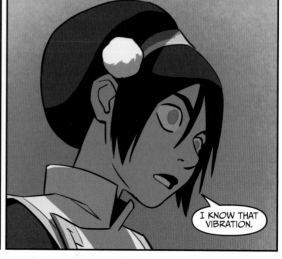

I KNOW THAT VIBRATION.

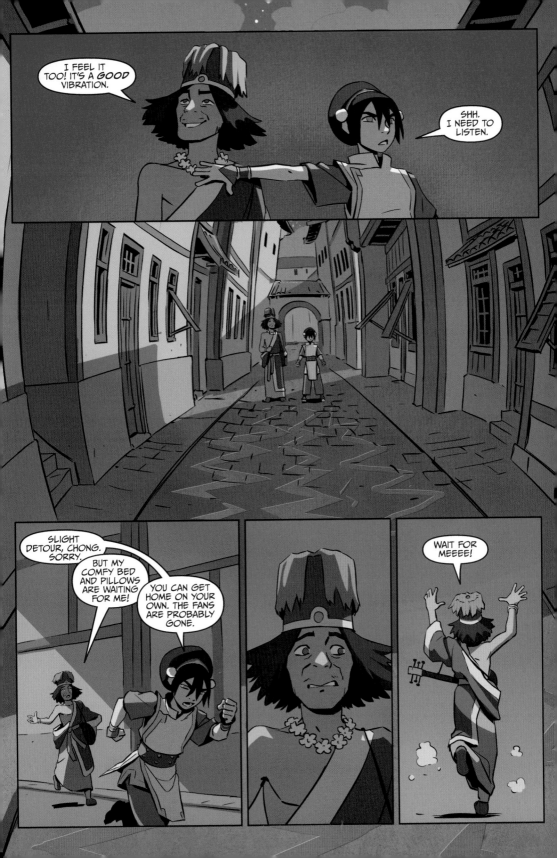

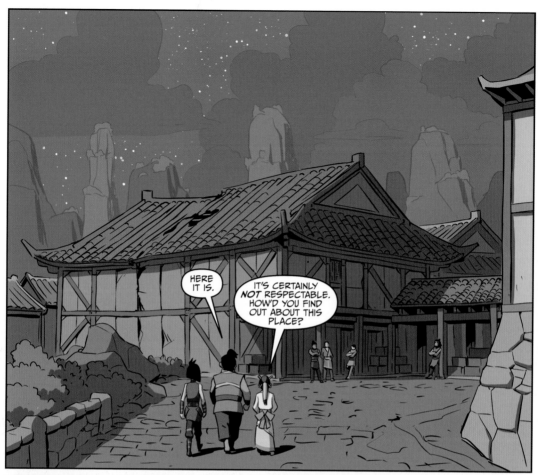

HERE IT IS.

IT'S CERTAINLY *NOT* RESPECTABLE. HOW'D YOU FIND OUT ABOUT THIS PLACE?

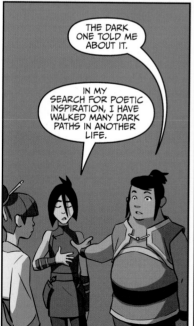

THE DARK ONE TOLD ME ABOUT IT.

IN MY SEARCH FOR POETIC INSPIRATION, I HAVE WALKED MANY DARK PATHS IN ANOTHER LIFE.

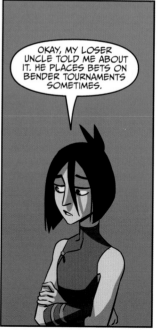

OKAY, MY LOSER UNCLE TOLD ME ABOUT IT. HE PLACES BETS ON BENDER TOURNAMENTS SOMETIMES.

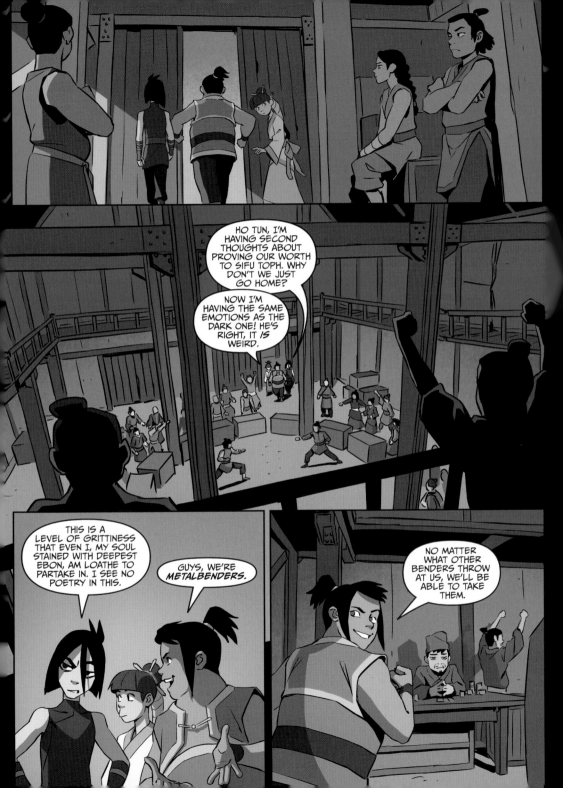

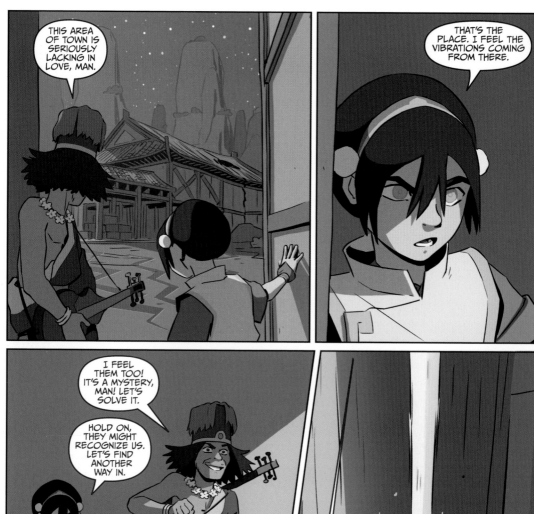
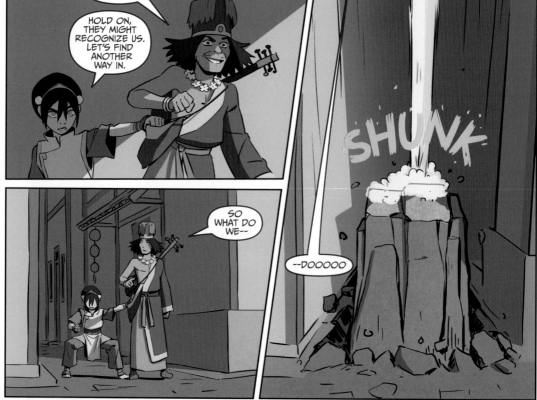

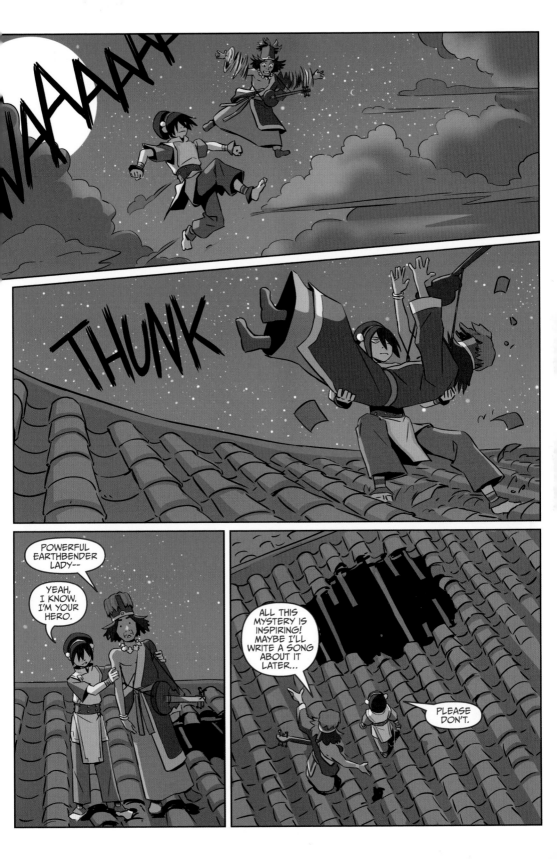

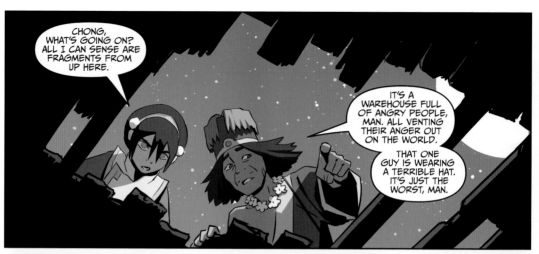

CHONG, WHAT'S GOING ON? ALL I CAN SENSE ARE FRAGMENTS FROM UP HERE.

IT'S A WAREHOUSE FULL OF ANGRY PEOPLE, MAN. ALL VENTING THEIR ANGER OUT ON THE WORLD.

THAT ONE GUY IS WEARING A TERRIBLE HAT. IT'S JUST THE WORST, MAN.

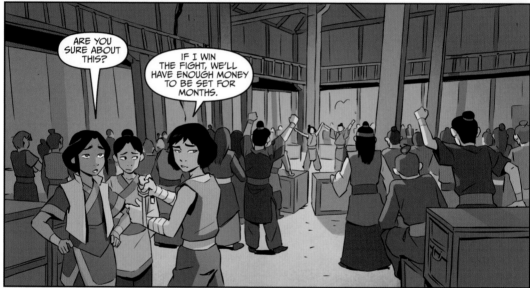

ARE YOU SURE ABOUT THIS?

IF I WIN THE FIGHT, WE'LL HAVE ENOUGH MONEY TO BE SET FOR MONTHS.

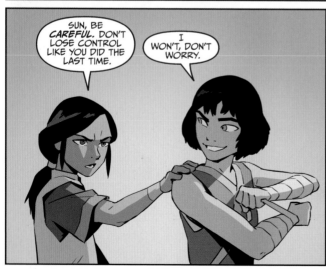

SUN, BE *CAREFUL*. DON'T LOSE CONTROL LIKE YOU DID THE LAST TIME.

I WON'T, DON'T WORRY.

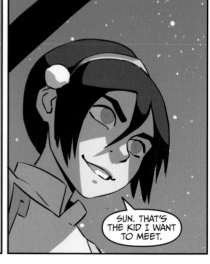

SUN. THAT'S THE KID I WANT TO MEET.

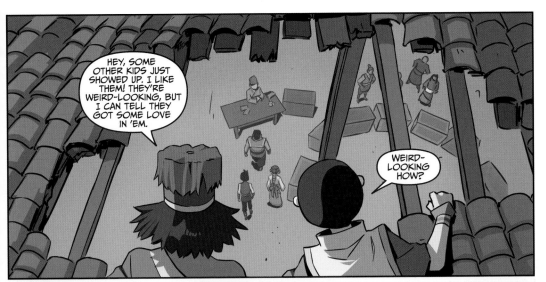

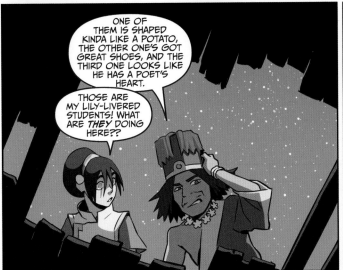

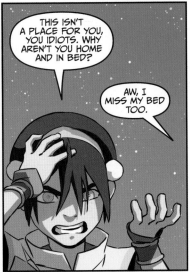

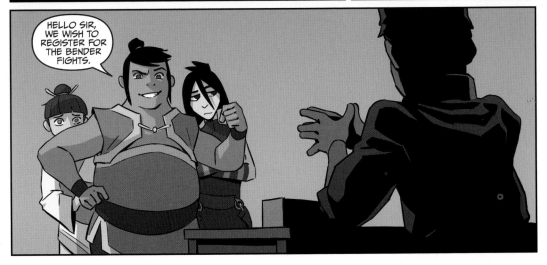

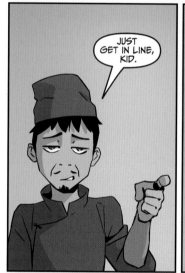

JUST GET IN LINE, KID.

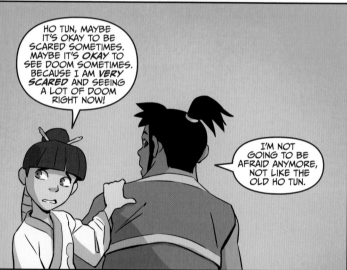

HO TUN, MAYBE IT'S OKAY TO BE SCARED SOMETIMES. MAYBE IT'S *OKAY* TO SEE DOOM SOMETIMES. BECAUSE I AM *VERY SCARED* AND SEEING A LOT OF DOOM RIGHT NOW!

I'M NOT GOING TO BE AFRAID ANYMORE, NOT LIKE THE OLD HO TUN.

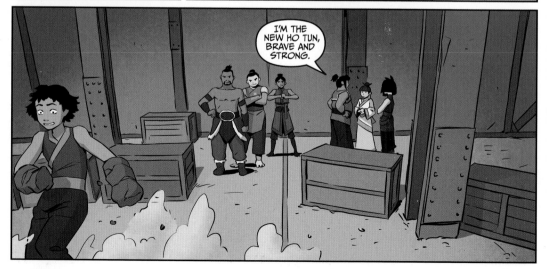

I'M THE NEW HO TUN, BRAVE AND STRONG.

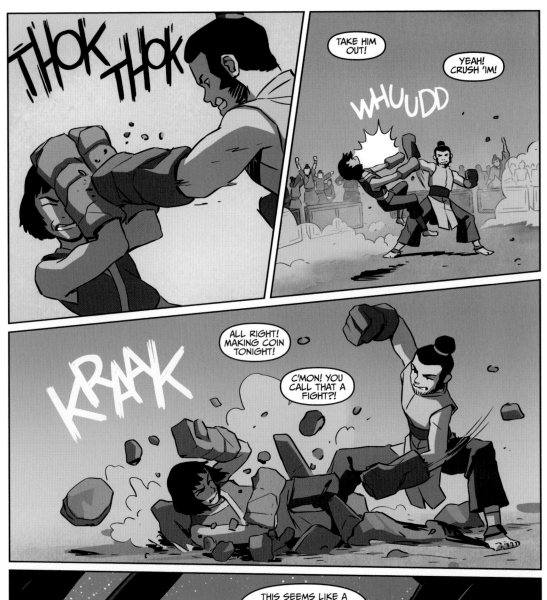

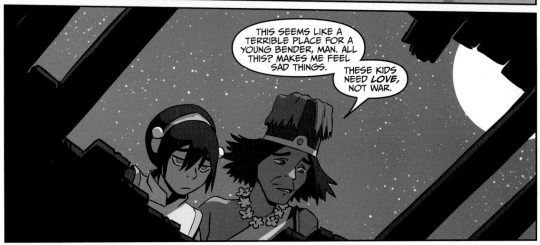

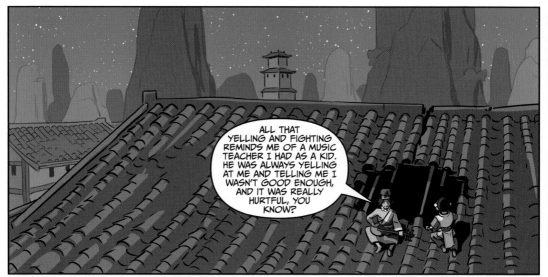

ALL THAT YELLING AND FIGHTING REMINDS ME OF A MUSIC TEACHER I HAD AS A KID. HE WAS ALWAYS YELLING AT ME AND TELLING ME I WASN'T GOOD ENOUGH, AND IT WAS REALLY HURTFUL, YOU KNOW?

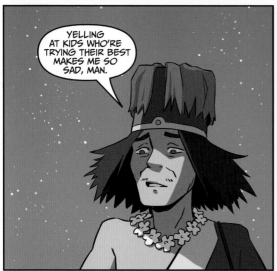

YELLING AT KIDS WHO'RE TRYING THEIR BEST MAKES ME SO SAD, MAN.

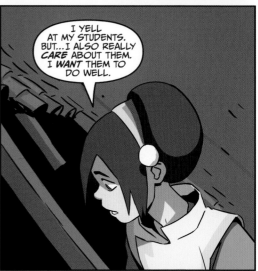

I YELL AT MY STUDENTS. BUT...I ALSO REALLY *CARE* ABOUT THEM. I *WANT* THEM TO DO WELL.

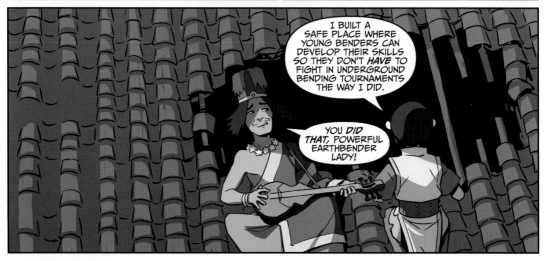

I BUILT A SAFE PLACE WHERE YOUNG BENDERS CAN DEVELOP THEIR SKILLS SO THEY DON'T *HAVE* TO FIGHT IN UNDERGROUND BENDING TOURNAMENTS THE WAY I DID.

YOU *DID THAT*, POWERFUL EARTHBENDER LADY!

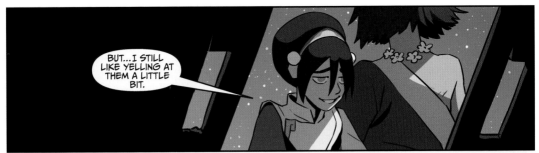

BUT...I STILL LIKE YELLING AT THEM A LITTLE BIT.

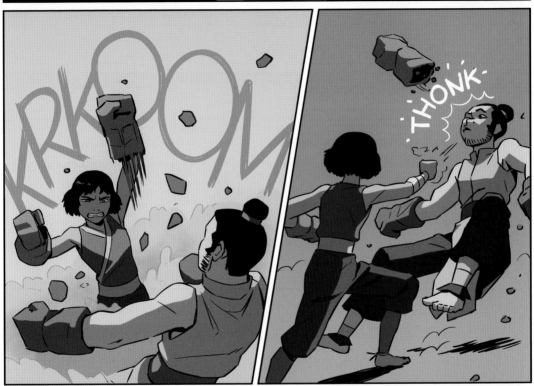

KRKOOM

THONK-

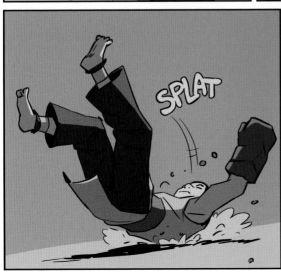

SPLAT

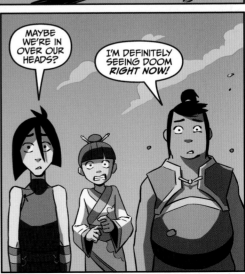

MAYBE WE'RE IN OVER OUR HEADS?

I'M DEFINITELY SEEING DOOM RIGHT NOW!

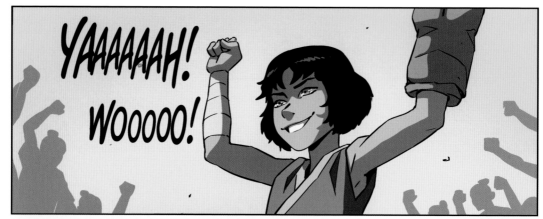

YAAAAAAH!
WOOOOO!

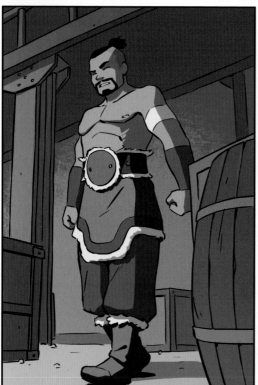

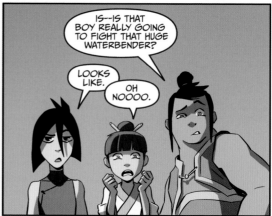

IS--IS THAT BOY REALLY GOING TO FIGHT THAT HUGE WATERBENDER?

LOOKS LIKE.

OH NOOOO.

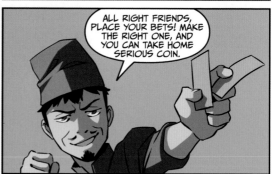

ALL RIGHT FRIENDS, PLACE YOUR BETS! MAKE THE RIGHT ONE, AND YOU CAN TAKE HOME SERIOUS COIN.

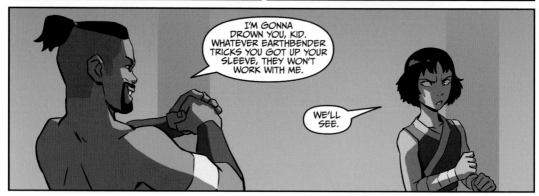

I'M GONNA DROWN YOU, KID. WHATEVER EARTHBENDER TRICKS YOU GOT UP YOUR SLEEVE, THEY WON'T WORK WITH ME.

WE'LL SEE.

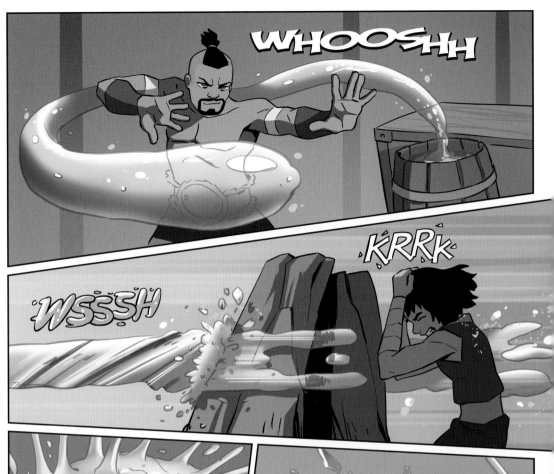

WHOOSHH

KRRK

WSSSH

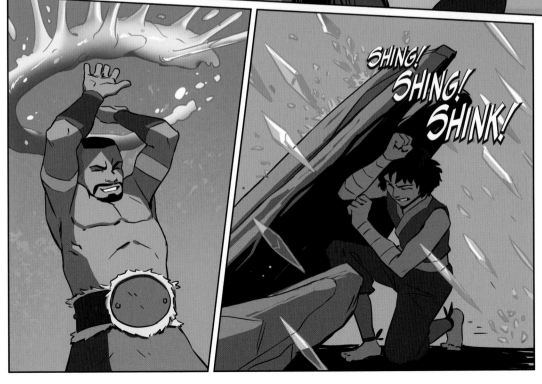

SHING!
SHING!
SHINK!

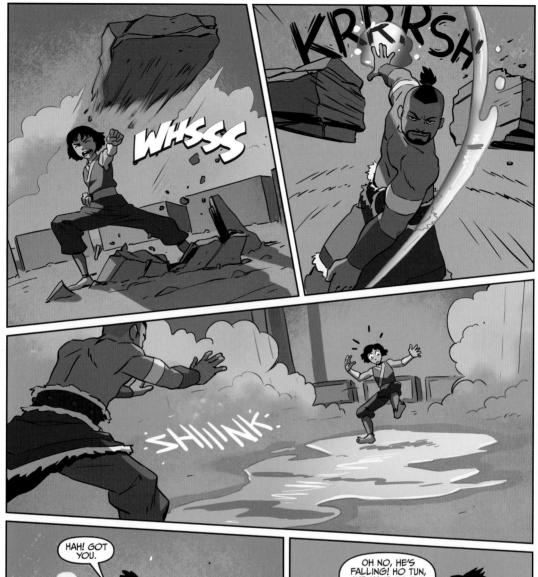

WHSSS

KRRRSH

SHIIINK.

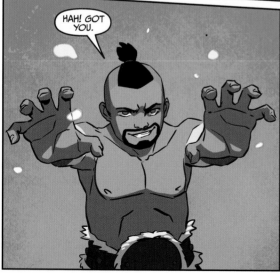

HAH! GOT YOU.

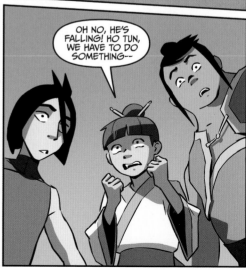

OH NO, HE'S FALLING! HO TUN, WE HAVE TO DO SOMETHING--

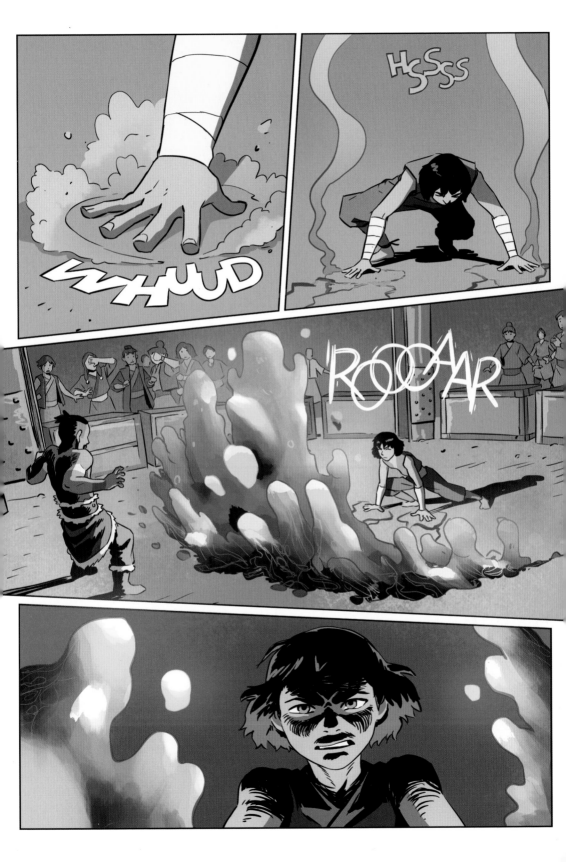

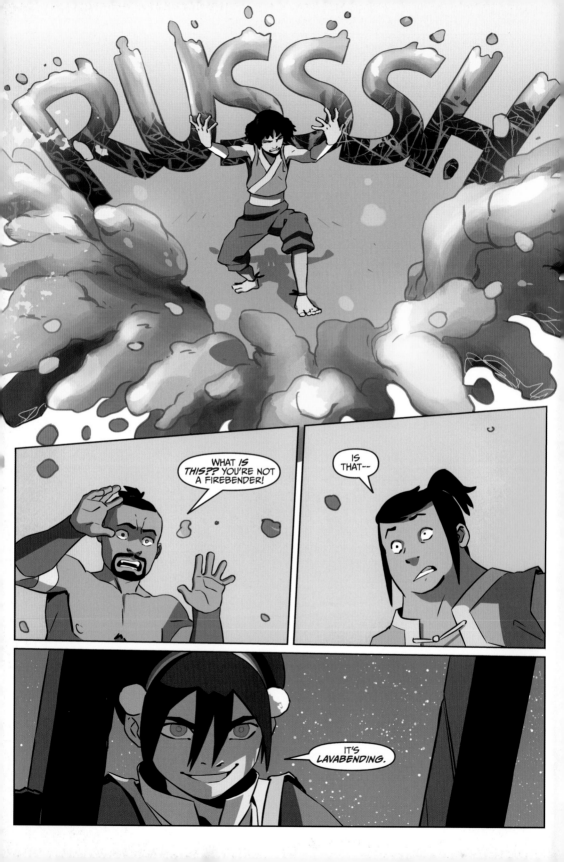

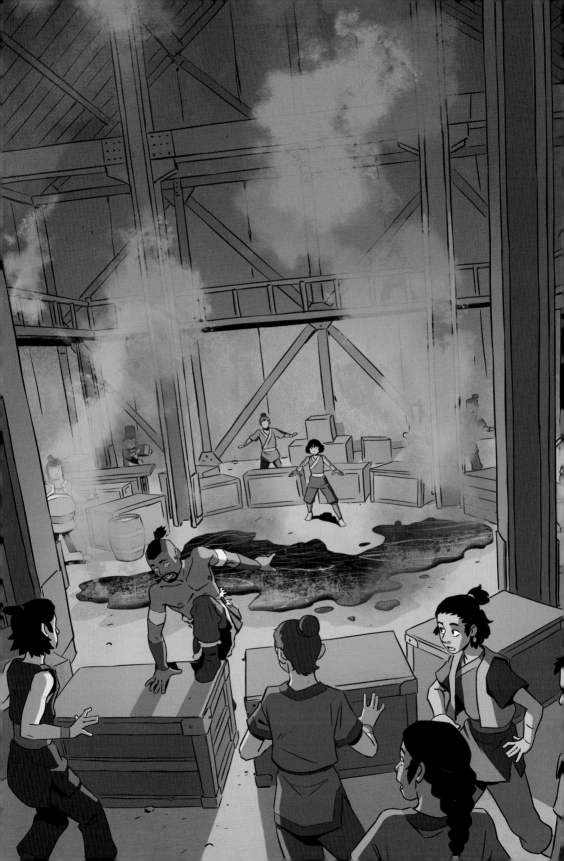

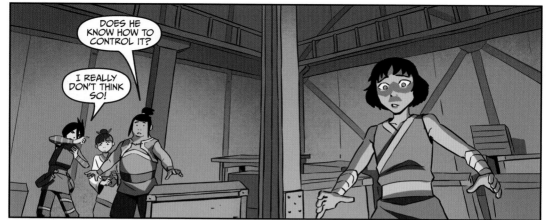

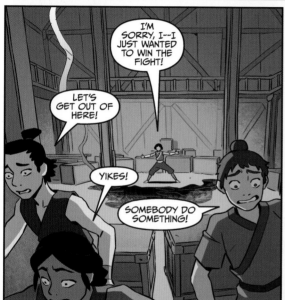

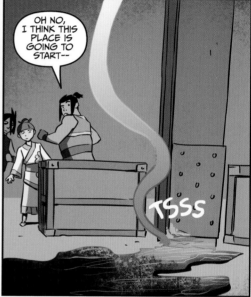

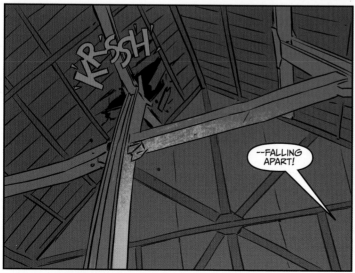

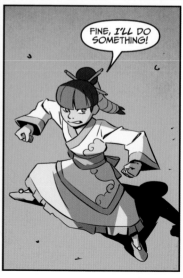

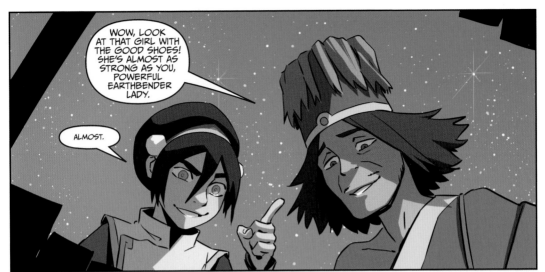

WOW, LOOK AT THAT GIRL WITH THE GOOD SHOES! SHE'S ALMOST AS STRONG AS YOU, POWERFUL EARTHBENDER LADY.

ALMOST.

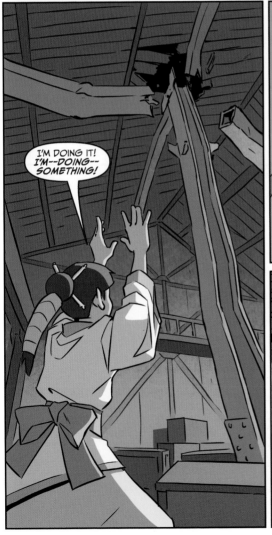

I'M DOING IT! I'M--DOING-- SOMETHING!

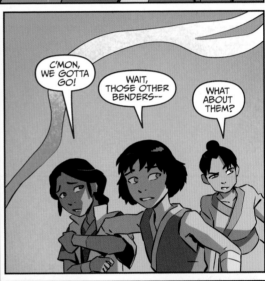

C'MON, WE GOTTA GO!

WAIT, THOSE OTHER BENDERS--

WHAT ABOUT THEM?

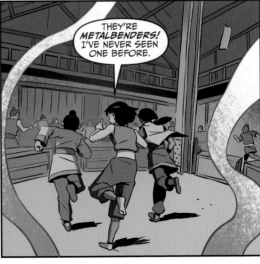

THEY'RE METALBENDERS! I'VE NEVER SEEN ONE BEFORE.

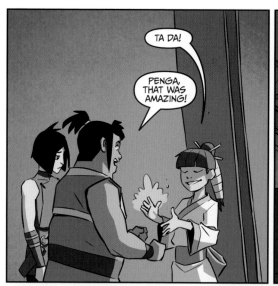

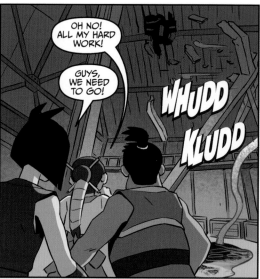

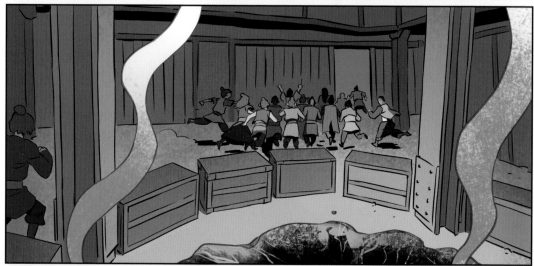

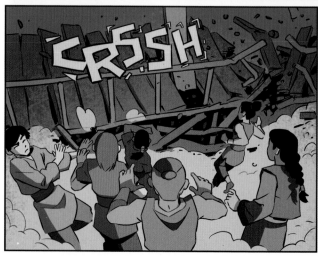

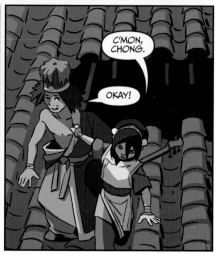

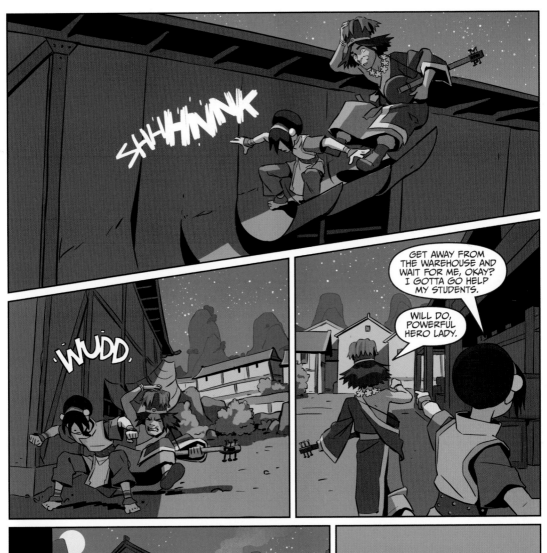

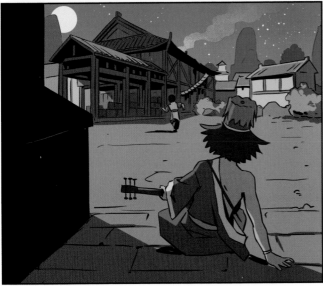

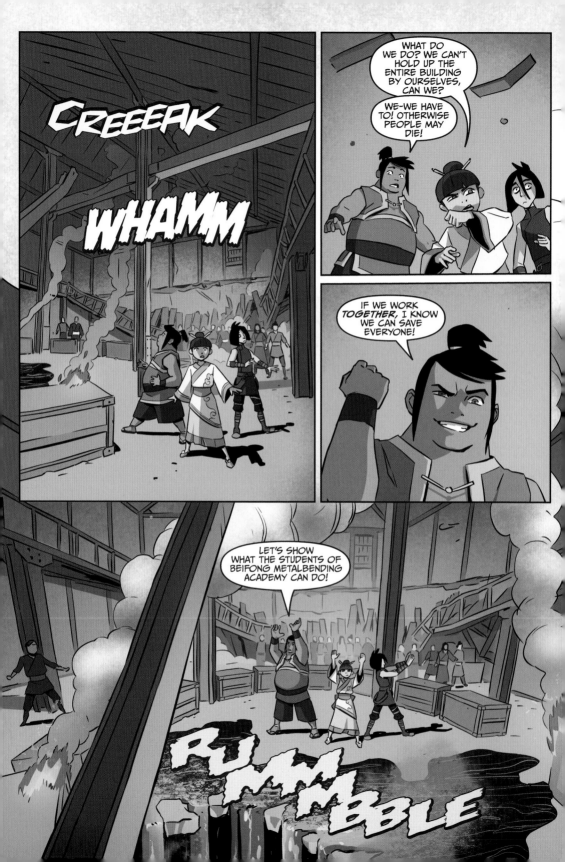

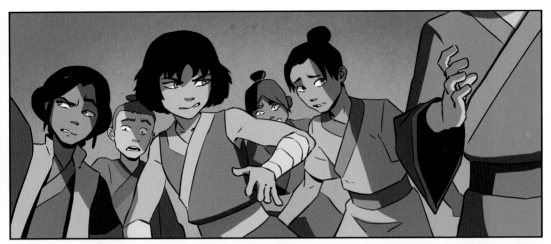

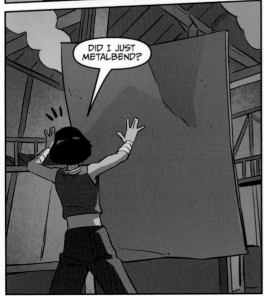

DID I JUST METALBEND?

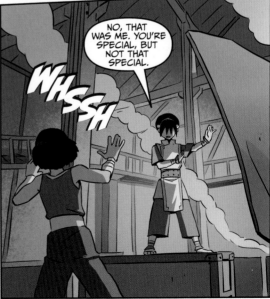

NO, THAT WAS ME. YOU'RE SPECIAL, BUT NOT THAT SPECIAL.

WHSSH

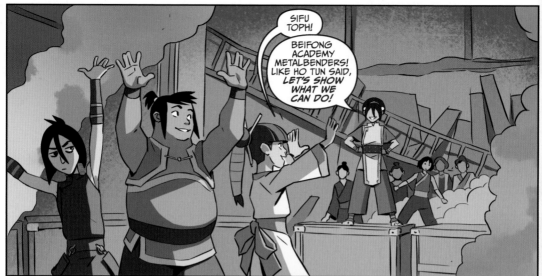

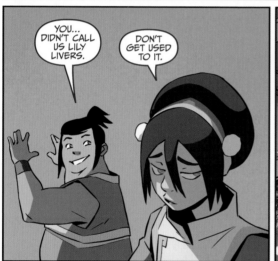

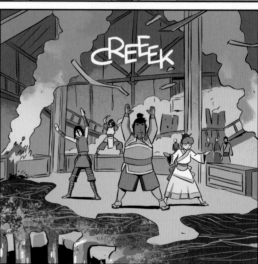

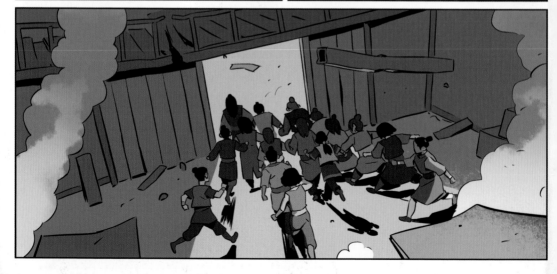

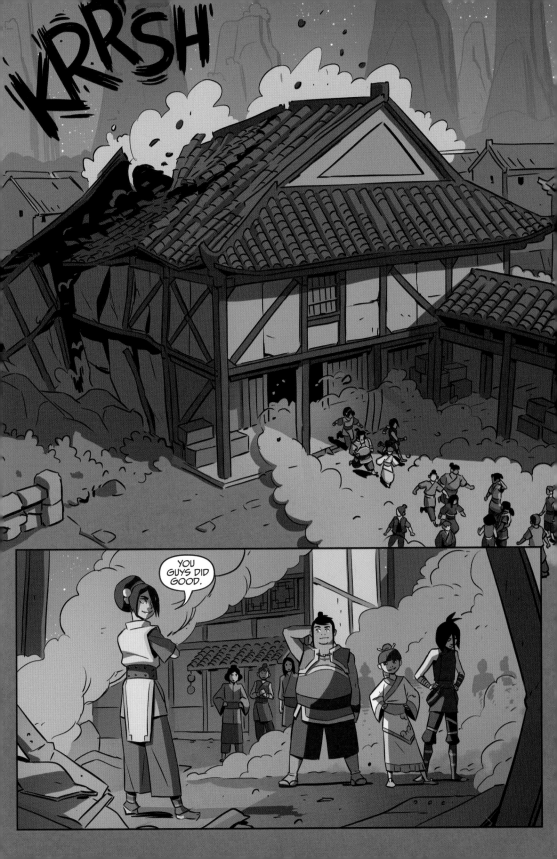

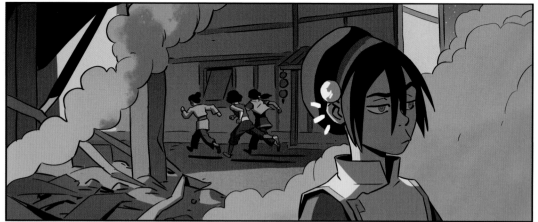

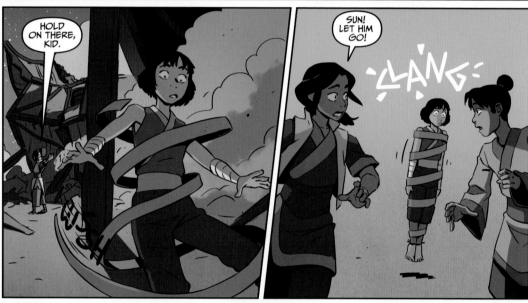

HOLD ON THERE, KID.

SUN! LET HIM GO!

SLANG

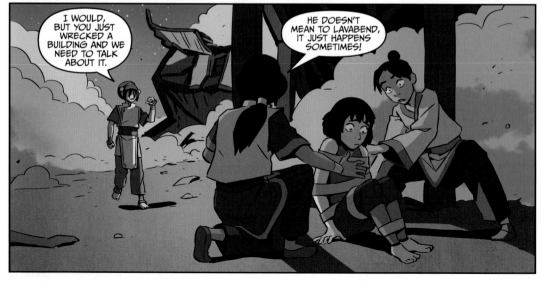

I WOULD, BUT YOU JUST WRECKED A BUILDING AND WE NEED TO TALK ABOUT IT.

HE DOESN'T MEAN TO LAVABEND, IT JUST HAPPENS SOMETIMES!

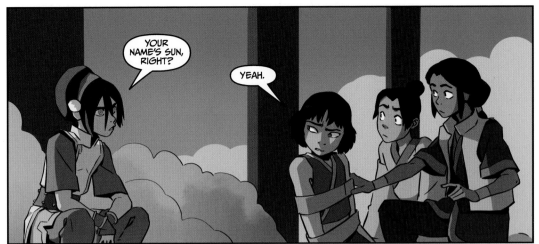

YOUR NAME'S SUN, RIGHT?

YEAH.

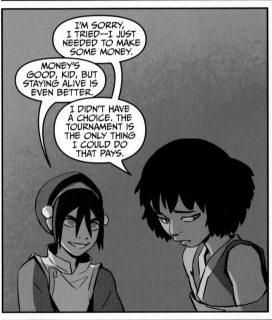

I'M SORRY, I TRIED--I JUST NEEDED TO MAKE SOME MONEY.

MONEY'S GOOD, KID, BUT STAYING ALIVE IS EVEN BETTER.

I DIDN'T HAVE A CHOICE. THE TOURNAMENT IS THE ONLY THING I COULD DO THAT PAYS.

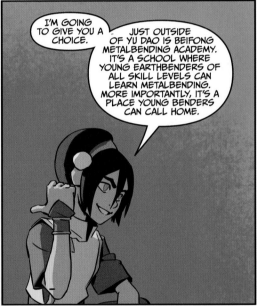

I'M GOING TO GIVE YOU A CHOICE.

JUST OUTSIDE OF YU DAO IS BEIFONG METALBENDING ACADEMY. IT'S A SCHOOL WHERE YOUNG EARTHBENDERS OF ALL SKILL LEVELS CAN LEARN METALBENDING. MORE IMPORTANTLY, IT'S A PLACE YOUNG BENDERS CAN CALL HOME.

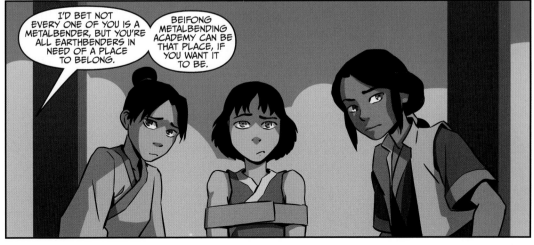

I'D BET NOT EVERY ONE OF YOU IS A METALBENDER, BUT YOU'RE ALL EARTHBENDERS IN NEED OF A PLACE TO BELONG.

BEIFONG METALBENDING ACADEMY CAN BE THAT PLACE, IF YOU WANT IT TO BE.

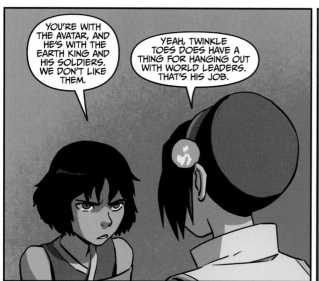

YOU'RE WITH THE AVATAR, AND HE'S WITH THE EARTH KING AND HIS SOLDIERS. WE DON'T LIKE THEM.

YEAH, TWINKLE TOES DOES HAVE A THING FOR HANGING OUT WITH WORLD LEADERS. THAT'S HIS JOB.

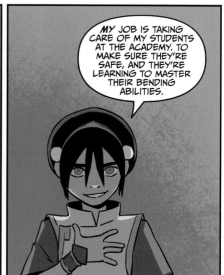

MY JOB IS TAKING CARE OF MY STUDENTS AT THE ACADEMY. TO MAKE SURE THEY'RE SAFE, AND THEY'RE LEARNING TO MASTER THEIR BENDING ABILITIES.

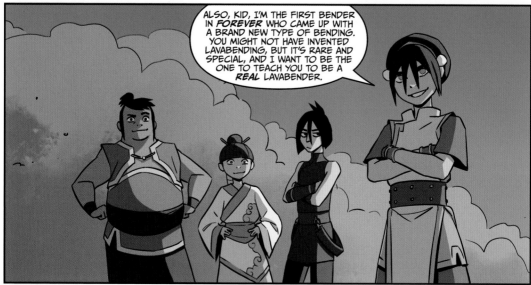

ALSO, KID, I'M THE FIRST BENDER IN *FOREVER* WHO CAME UP WITH A BRAND NEW TYPE OF BENDING. YOU MIGHT NOT HAVE INVENTED LAVABENDING, BUT IT'S RARE AND SPECIAL, AND I WANT TO BE THE ONE TO TEACH YOU TO BE A *REAL* LAVABENDER.

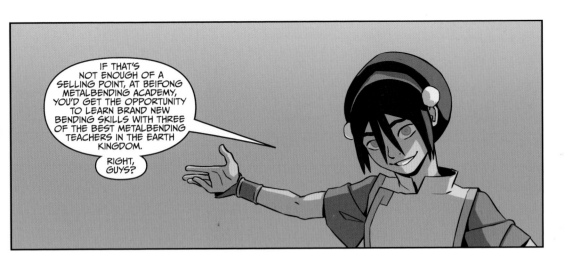

IF THAT'S NOT ENOUGH OF A SELLING POINT, AT BEIFONG METALBENDING ACADEMY, YOU'D GET THE OPPORTUNITY TO LEARN BRAND NEW BENDING SKILLS WITH THREE OF THE BEST METALBENDING TEACHERS IN THE EARTH KINGDOM.

RIGHT, GUYS?

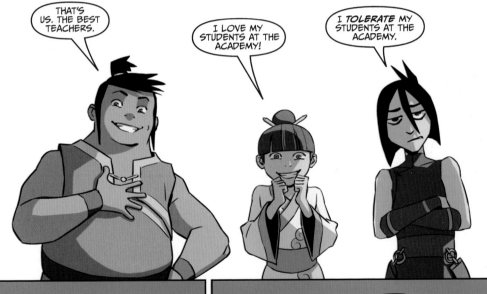

THAT'S US. THE BEST TEACHERS.

I LOVE MY STUDENTS AT THE ACADEMY!

I *TOLERATE* MY STUDENTS AT THE ACADEMY.

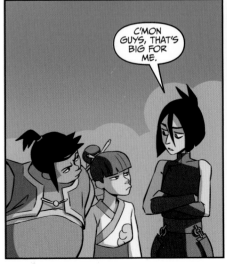

C'MON GUYS, THAT'S BIG FOR ME.

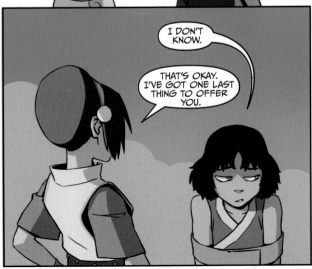

I DON'T KNOW.

THAT'S OKAY. I'VE GOT ONE LAST THING TO OFFER YOU.

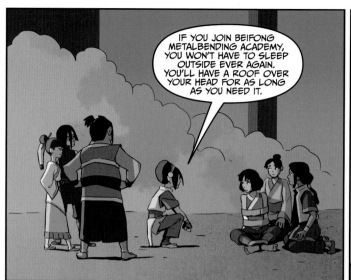

IF YOU JOIN BEIFONG METALBENDING ACADEMY, YOU WON'T HAVE TO SLEEP OUTSIDE EVER AGAIN. YOU'LL HAVE A ROOF OVER YOUR HEAD FOR AS LONG AS YOU NEED IT.

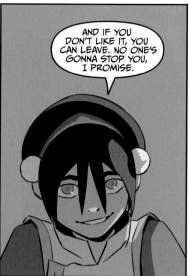

AND IF YOU DON'T LIKE IT, YOU CAN LEAVE. NO ONE'S GONNA STOP YOU, I PROMISE.

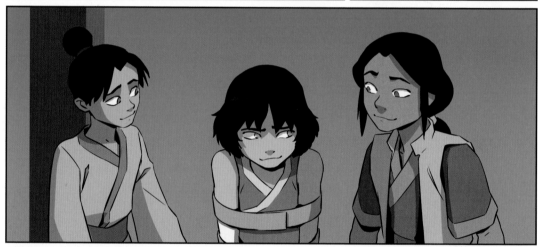

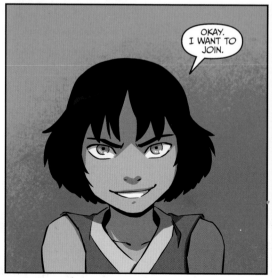

OKAY. I WANT TO JOIN.

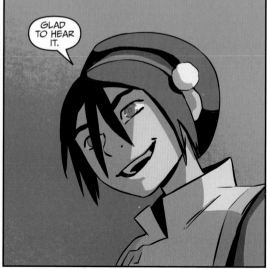

GLAD TO HEAR IT.

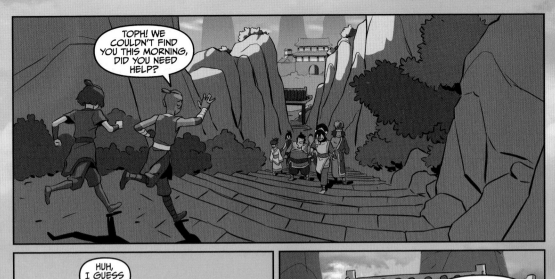

TOPH! WE COULDN'T FIND YOU THIS MORNING, DID YOU NEED HELP?

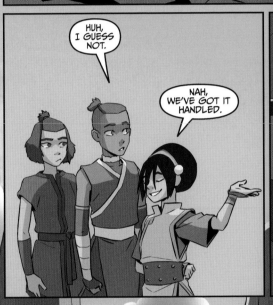

HUH, I GUESS NOT.

NAH, WE'VE GOT IT HANDLED.

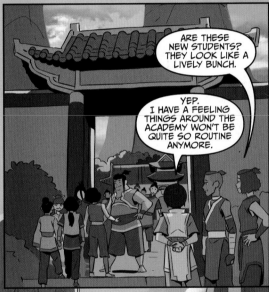

ARE THESE NEW STUDENTS? THEY LOOK LIKE A LIVELY BUNCH.

YEP. I HAVE A FEELING THINGS AROUND THE ACADEMY WON'T BE QUITE SO ROUTINE ANYMORE.

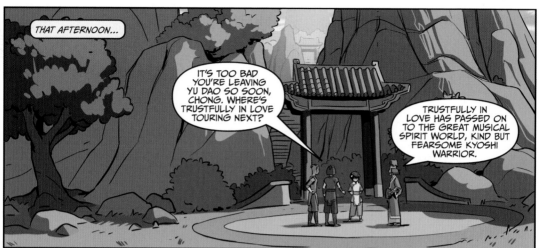

THAT AFTERNOON...

IT'S TOO BAD YOU'RE LEAVING YU DAO SO SOON, CHONG. WHERE'S TRUSTFULLY IN LOVE TOURING NEXT?

TRUSTFULLY IN LOVE HAS PASSED ON TO THE GREAT MUSICAL SPIRIT WORLD, KIND BUT FEARSOME KYOSHI WARRIOR.

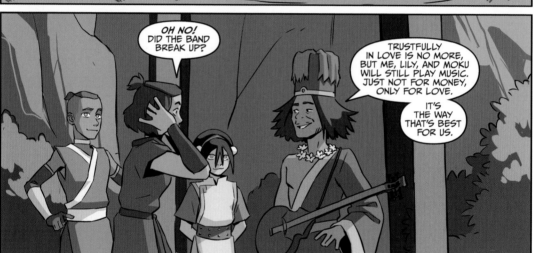

OH NO! DID THE BAND BREAK UP?

TRUSTFULLY IN LOVE IS NO MORE, BUT ME, LILY, AND MOKU WILL STILL PLAY MUSIC. JUST NOT FOR MONEY, ONLY FOR LOVE.

IT'S THE WAY THAT'S BEST FOR US.

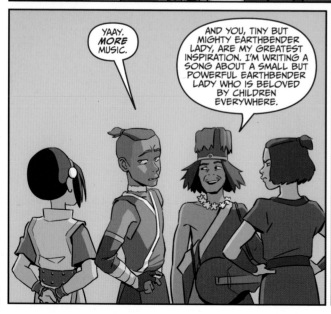

YAAY. *MORE* MUSIC.

AND YOU, TINY BUT MIGHTY EARTHBENDER LADY, ARE MY GREATEST INSPIRATION. I'M WRITING A SONG ABOUT A SMALL BUT POWERFUL EARTHBENDER LADY WHO IS BELOVED BY CHILDREN EVERYWHERE.

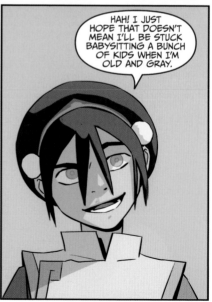

HAH! I JUST HOPE THAT DOESN'T MEAN I'LL BE STUCK BABYSITTING A BUNCH OF KIDS WHEN I'M OLD AND GRAY.

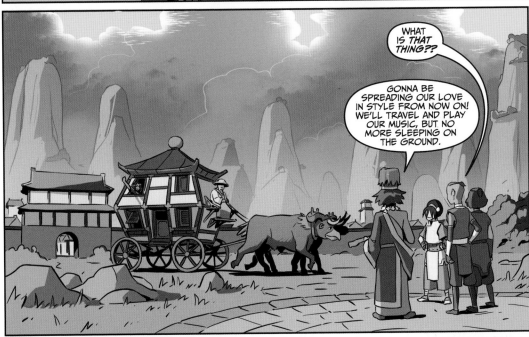

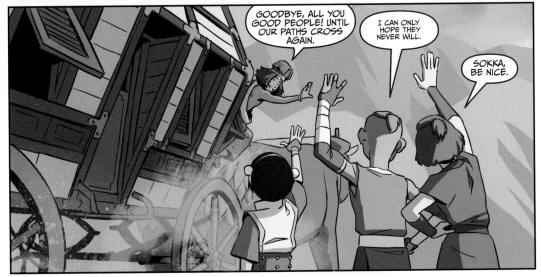

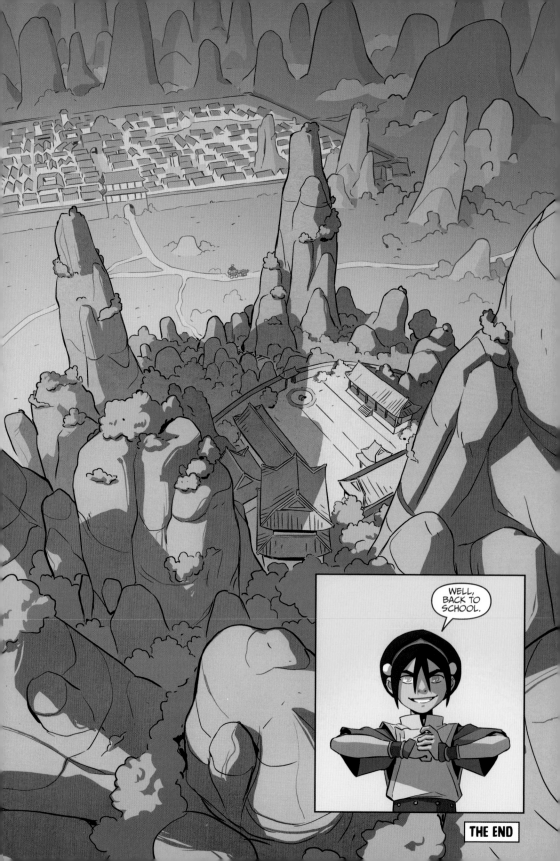

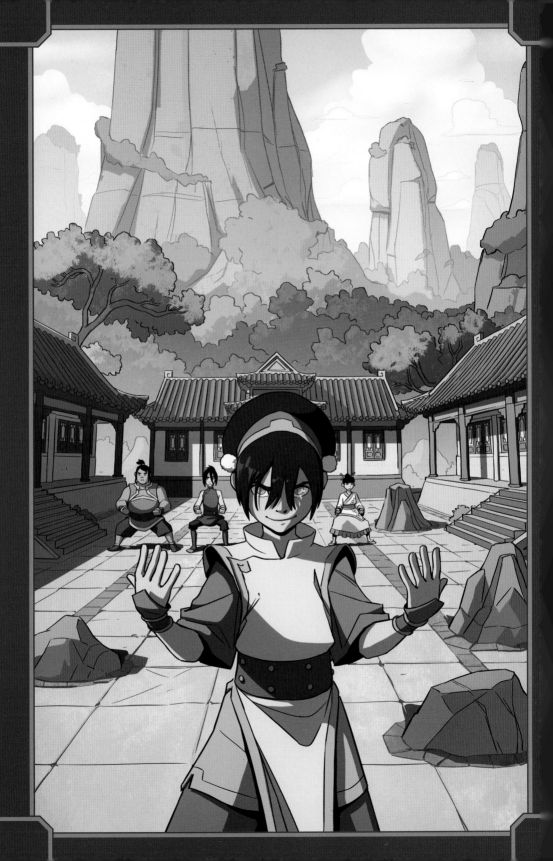

**Avatar: The Last Airbender—
The Promise
Library Edition**
978-1-61655-074-5 $39.99

**Avatar: The Last Airbender—
The Promise Part 1**
978-1-59582-811-8 $12.99

**Avatar: The Last Airbender—
The Promise Part 2**
978-1-59582-875-0 $12.99

**Avatar: The Last Airbender—
The Promise Part 3**
978-1-59582-941-2 $12.99

**Avatar: The Last Airbender—
The Search
Library Edition**
978-1-61655-226-8 $39.99

**Avatar: The Last Airbender—
The Search Part 1**
978-1-61655-054-7 $12.99

**Avatar: The Last Airbender—
The Search Part 2**
978-1-61655-190-2 $12.99

**Avatar: The Last Airbender—
The Search Part 3**
978-1-61655-184-1 $12.99

**Avatar: The Last Airbender—
The Rift
Library Edition**
978-1-61655-550-4 $39.99

**Avatar: The Last Airbender—
The Rift Part 1**
978-1-61655-295-4 $12.99

**Avatar: The Last Airbender—
The Rift Part 2**
978-1-61655-296-1 $12.99

**Avatar: The Last Airbender—
The Rift Part 3**
978-1-61655-297-8 $12.99

**Avatar: The Last Airbender—
Smoke and Shadow
Library Edition**
978-1-50670-013-7 $39.99

**Avatar: The Last Airbender—
Smoke and Shadow Part 1**
978-1-61655-761-4 $12.99

**Avatar: The Last Airbender—
Smoke and Shadow Part 2**
978-1-61655-790-4 $12.99

**Avatar: The Last Airbender—
Smoke and Shadow Part 3**
978-1-61655-838-3 $12.99

**Avatar: The Last Airbender—
North and South
Library Edition**
978-1-50670-195-0 $39.99

**Avatar: The Last Airbender—
North and South Part 1**
978-1-50670-022-9 $12.99

**Avatar: The Last Airbender—
North and South Part 2**
978-1-50670-129-5 $12.99

**Avatar: The Last Airbender—
North and South Part 3**
978-1-50670-130-1 $12.99